HEART OF A SMALL TOWN

HEART OF A SMALL TOWN

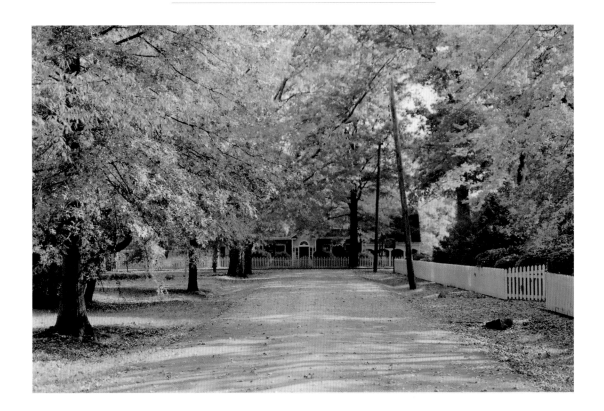

PHOTOGRAPHS OF ALABAMA TOWNS

ROBIN McDONALD

Foreword by Robert Gamble

THE UNIVERSITY OF ALABAMA PRESS

Tuscaloosa and London

Designer: Robin McDonald
Typeface: Berkeley Oldstyle

∞

The paper on which this book is printed meets the minimum require-
ments of American National Standard for Information Science–
Permanence of Paper for Printed Library Materials, ANSI Z39.48-1984.

Library of Congress Cataloging-in-Publication Data

McDonald, Robin, 1951–
 Heart of a small town : photographs of Alabama towns / Robin
McDonald ; foreword by Robert Gamble.
 p. cm.
 ISBN 0-8173-1375-3 (alk. paper) — ISBN 0-8173-5055-1 (pbk. : alk.
paper)
 1. Alabama—History, Local—Pictorial works. 2. Alabama—Social life
and customs—Pictorial works. 3. City and town life—Alabama—Pictorial
works. 4. Alabama—Social life and customs—Quotations, maxims, etc.
5. City and town life—Alabama—Quotations, maxims, etc. I. Title.
 F326M36 2003
 976.1'009732'022—dc21

 2003045516

British Library Cataloguing-in-Publication Data available

To Debbie, Christopher, and Shaun, for your love and (almost) unending patience.

FOREWORD

IN THE IMAGES THAT FILL THE FOLLOWING
pages, photographer Robin McDonald has rendered from ordinary things
an extraordinary portrait of small town life. His subject happens to be a
single state in the Deep South, but the themes his photographs suggest are
universal. In fact, as I fell gradually under the spell of these vibrant pic-
tures—pictures so charged with life and color that at times they seem to
leap from the page—I found myself thinking about a town in Latin America
where I lived many years ago. Of course the landscape and the architecture
and even most of the details were different. But Robin's images suggested an
underlying pulse-beat of human existence that was the same: a rhythm of
hope, florescence, and decay lived out in communities around the globe. It
is all the more remarkable that his photographs manage to do so without
introducing a single human form or face. "Life all around me here in the
village," wrote Midwestern poet Edgar Lee Masters. "All in the loom, and
oh what patterns!" This is the mood of Robin McDonald's photographs,
animated and enriched by lyrical quotations borrowed from an array of south-
ern writers from the nearly forgotten Augusta Evans Wilson to the well-known
Truman Capote, Harper Lee, and Rick Bragg.

At the same time this is a book that can be enjoyed on a number of
levels: as sheer visual artistry, as a snapshot of "place," as recollection, or
even as portent. Robin says, simply, that he photographs the things he loves,
seemingly random details and commonplace scenes he has encountered on
weekend rambles or chance visits to towns the length and breadth of Ala-
bama. Yet the composite portrait is fresh and unexpected.

This may be, in part, because Robin himself is an outlander. He grew up in the suburbs of London and only came to Alabama as a teenager. Thus his has been a photographic journey of discovery in a strange new environment—one quintessentially American in some respects and more like the Third World in others. There is a whiff—a very tiny whiff—of the mythic South of sun-bathed white columns and somber Confederate memorials eternally mourning a lost idea, of Tobacco Road poverty and ingrained racism. There is hardly anything of the newly minted, homogenizing Sunbelt South of WalMart sprawl and unremitting roadside ugliness. On the whole, Robin's images search deeper and scrutinize more closely.

Those of us who are natives to this soil will find special pleasure in the way the photographs draw us into a rediscovery of the familiar, or stop us in our tracks to look with a new eye at the most prosaic detail: a cracked sidewalk, for instance, beneath the partially open screened door of an old store. And as we turn the pages, we may confront scenes that we realize now, in retrospect, suffused the days of our childhood: the Art Deco ticket booth at the picture show; a barbershop decked out in red, white, and blue; a Frigidaire neon sign; the rusty hulk of a forsaken Chevrolet truck; a scattering of newly fallen leaves on a quiet street; or more intimately, a leaden sky and bare winter branches glimpsed beyond a lace-curtained window, a bridal dress reflected through plate glass, the slightly disheveled kneelers at the altar rail of a village church, hand-woven baskets on bare-board walls. And always greenery emerges, the rampant greenery of long, hot summer days, creeping up a corrugated tin wall, arching over sidewalks and verandas, tunneling along a red clay road. It is a world that has changed and is changing—profoundly—that is dying in gentle decrepitude and, at the same time, being reborn into something new. This is the world that Robin McDonald has explored with the soul of a poet and now shows us through the discerning eye of a gifted artist in *Heart of a Small Town*.

—Robert Gamble

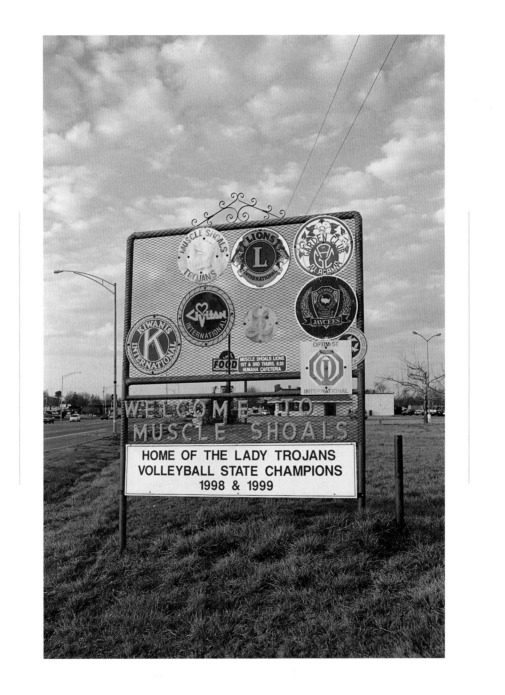

I HAD FALLEN INTO THE HABIT of visiting Mrs. Kent on Wednesday afternoons, and it soon became an established fact that I was expected on that day. She received me on the wide porch which opened onto her garden, and while she fixed my tea and offered me the small, pecan cakes I liked so well, she told me of the town and its people.

—WILLIAM MARCH
"Not Worthy of a Wentworth"

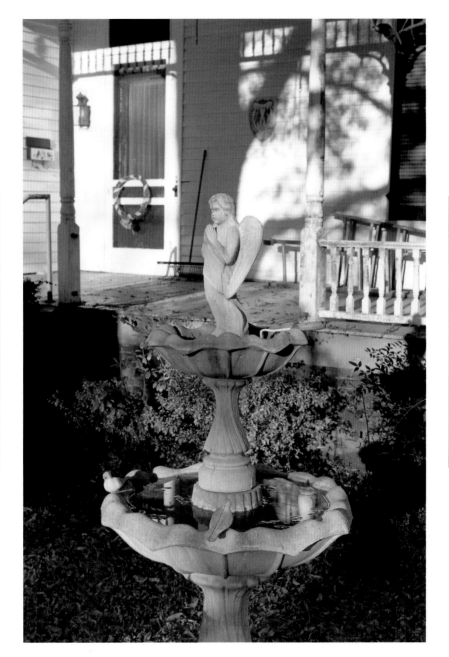

SELMA

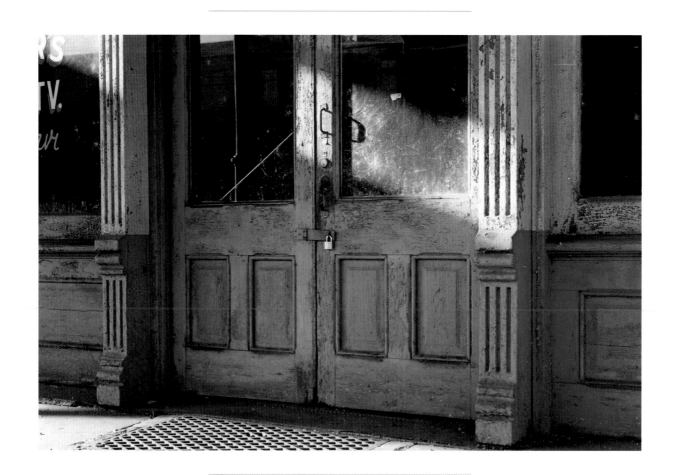

SELMA

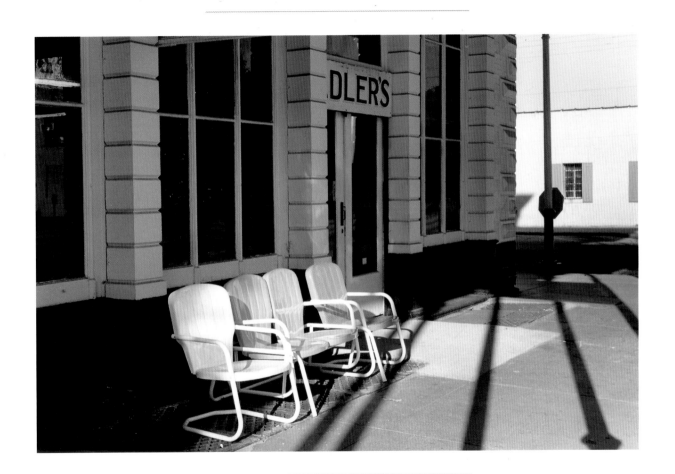

SELMA

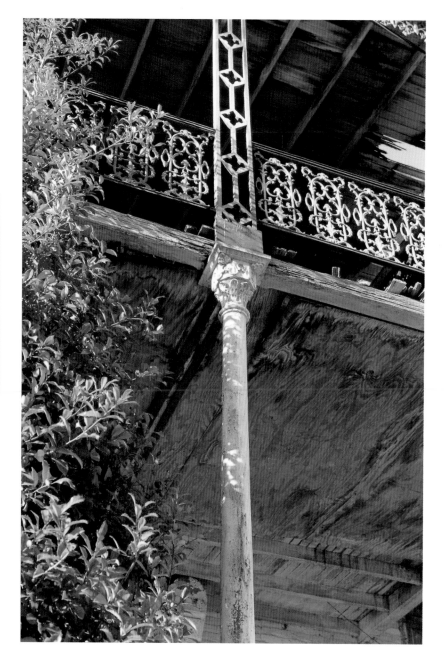

SELMA

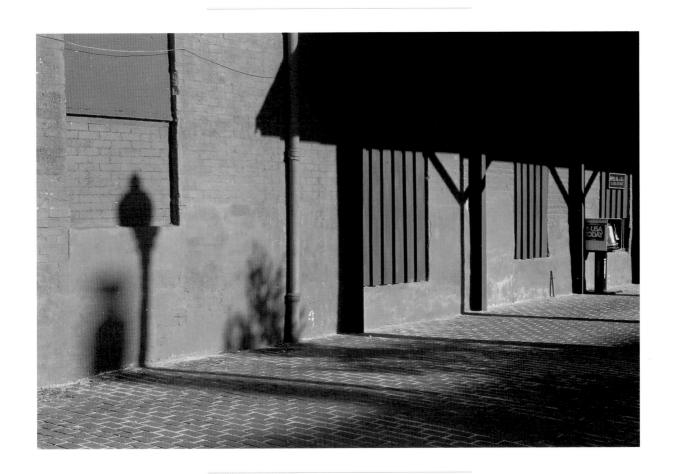

SELMA

LIKE MANY DEEP SOUTH towns, Camden is both blessed and burdened with a past. Blessed because of a goodly heritage that the past has bestowed upon it, burdened because much of the past is painful and will not die.

—VIOLA GOODE LIDDELL
A Place of Springs

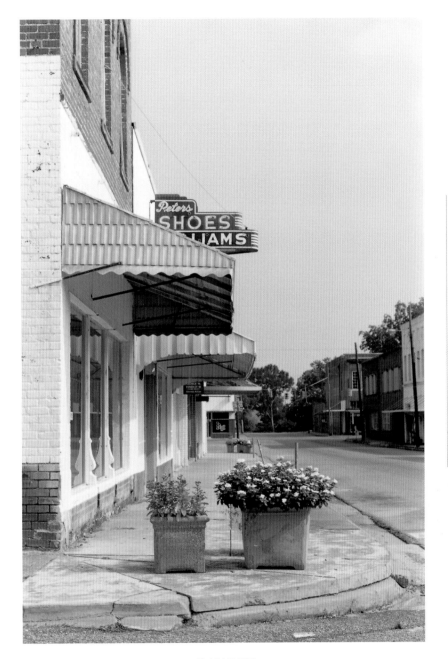

CAMDEN

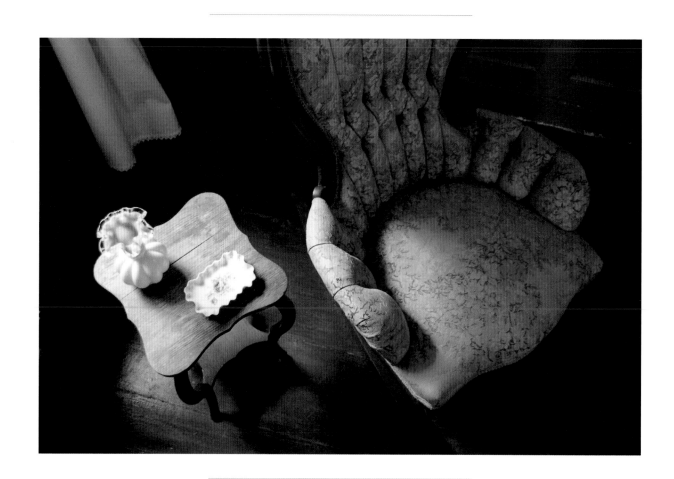

CAMDEN

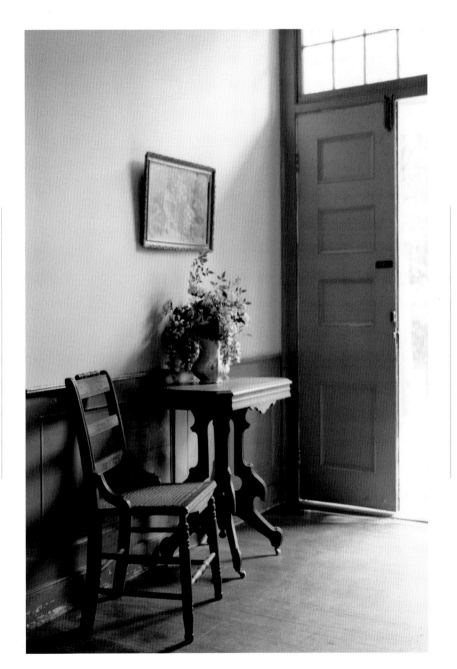

CAMDEN

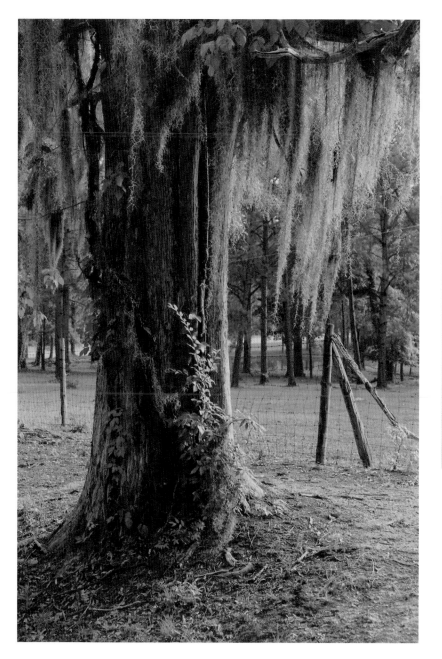

CAMDEN

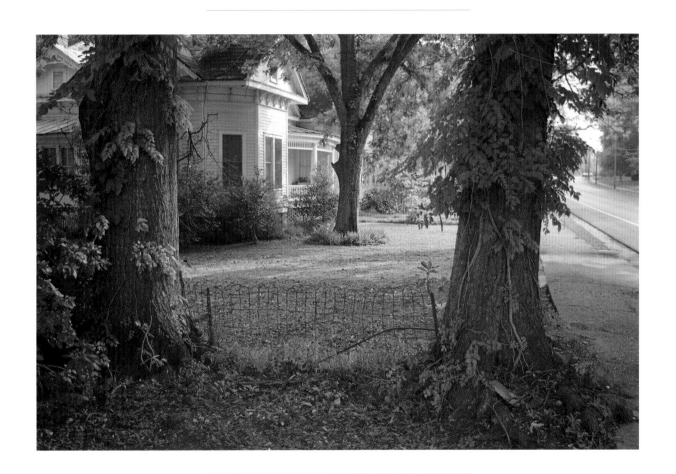

CAMDEN

PEOPLE MOVED SLOWLY THEN.

They ambled across the square, shuffled in and out of the stores around it, took their time about everything. A day was twenty-four hours long but seemed longer. There was no hurry, for there was nowhere to go, nothing to buy and no money to buy it with.

—HARPER LEE
To Kill a Mockingbird

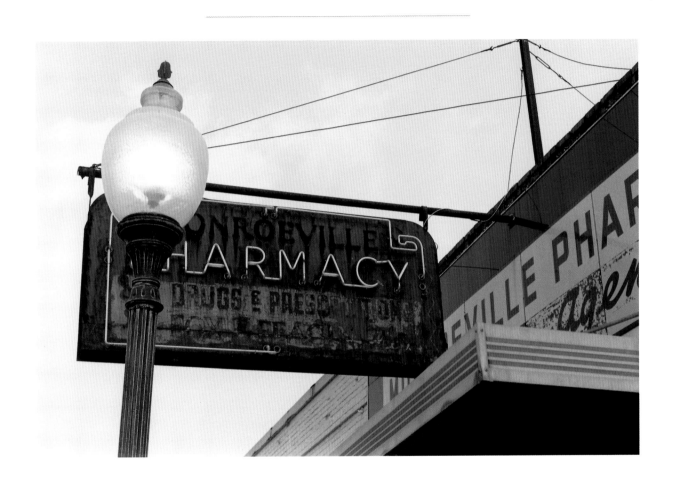

MONROEVILLE

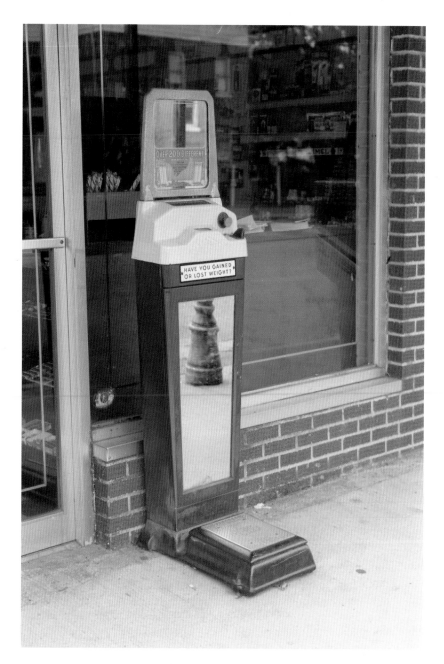

MONROEVILLE

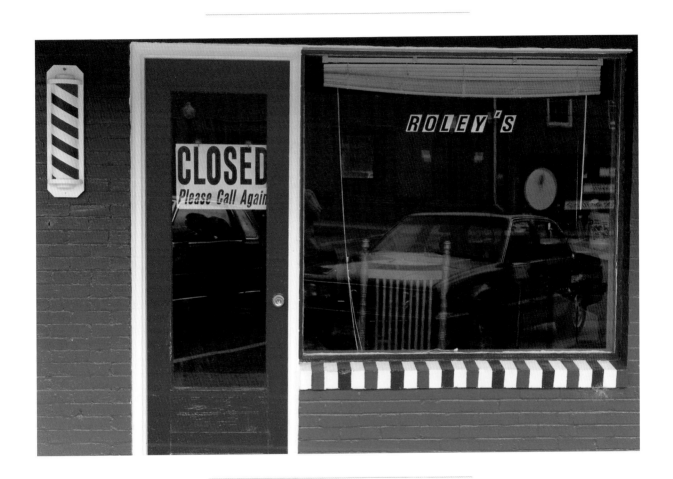

MONROEVILLE

THE RITZIEST PLACE I HAD ever been inside was the dime store on the old courthouse square. It was run by two ancient sisters. I would walk the aisles, looking at the toys and worthless knickknacks and magazine rack, which I was not allowed to touch. The old women tracked me with their eyes, every step I made. At ten-minute intervals one of the old women would ask if they could help me. "No ma'am," I would say, "I'm just lookin'."

—RICK BRAGG

All Over but the Shoutin'

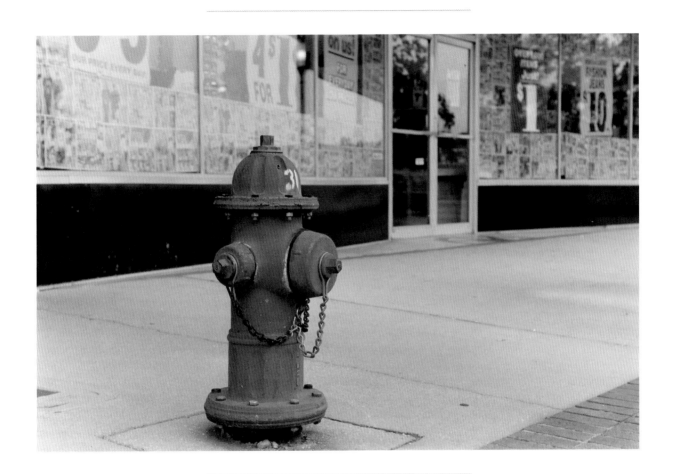

MONROEVILLE

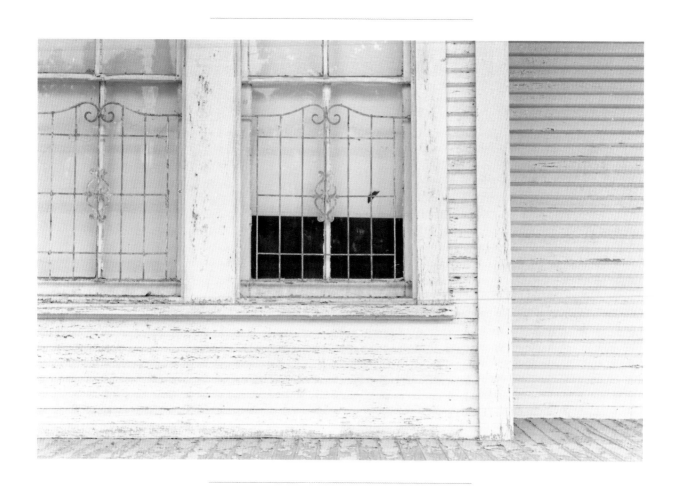

MONROEVILLE

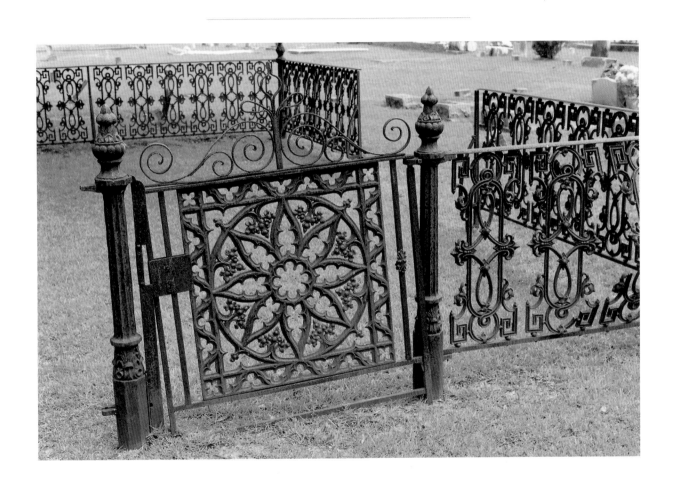

MONROEVILLE

I LIVED WITH MY GRAND-
parents on the edge of town in a frame house on
Westview Street. It wasn't much of a street, really, and
when it rained too hard it was impassable to all
except the most determined pedestrian traffic. Yet
we were only two blocks from the edge of the white
community—"where the sidewalk begins"—and
scarcely eight or ten blocks from Courthouse Square,
the center of the town itself.

—C. ERIC LINCOLN
"Coming through the Fire"

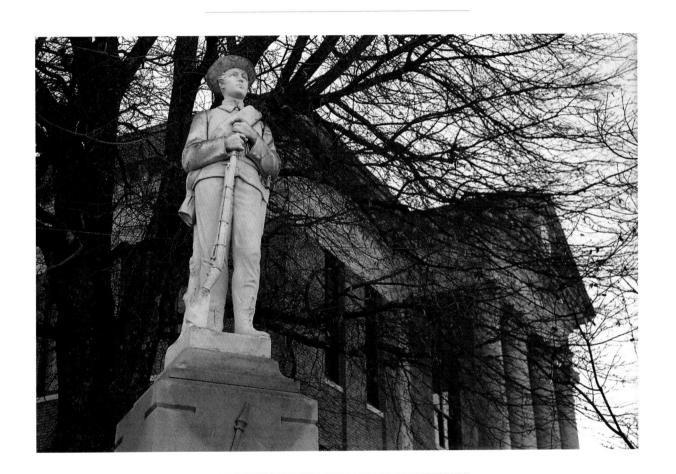

ATHENS

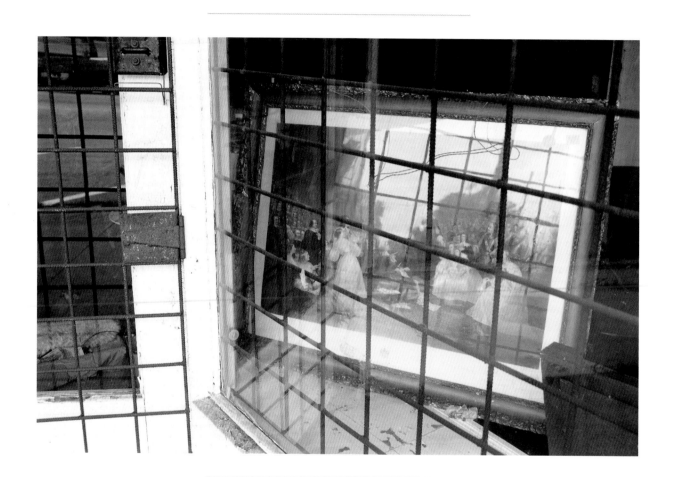

MARION

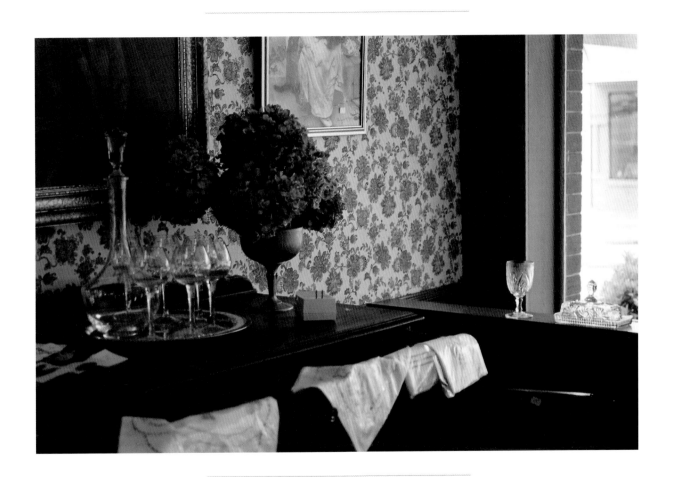

MARION

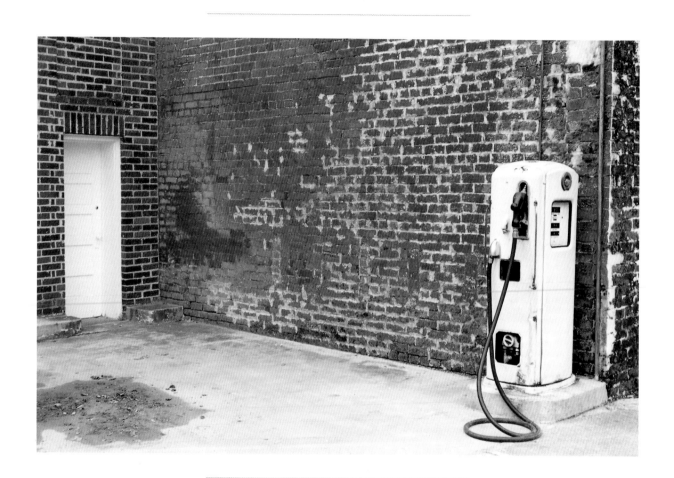

MARION

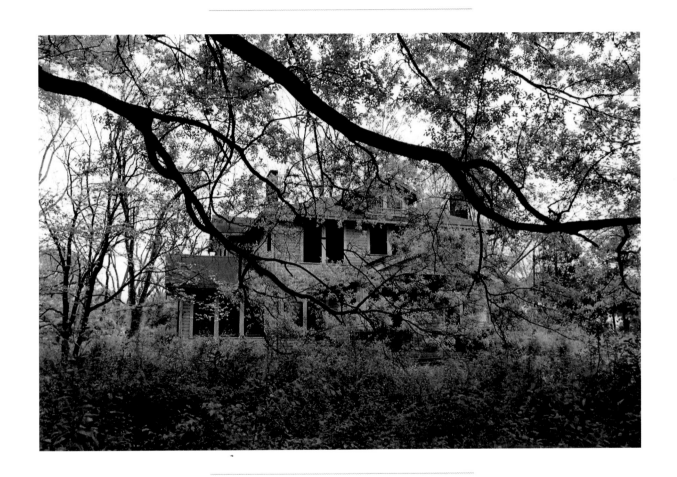

MARION

WE ALL GOT MESMERIZED looking at the Alabama landscape, the cotton fields, the kudzu, the red clay, the pines, the little semi-towns that you could not tell if they were just getting started or just giving up, the big houses with the tree-lined drives, and the little shacks clustered together under one huge old shade tree.

—NANCI KINCAID
"The Other Son of God"

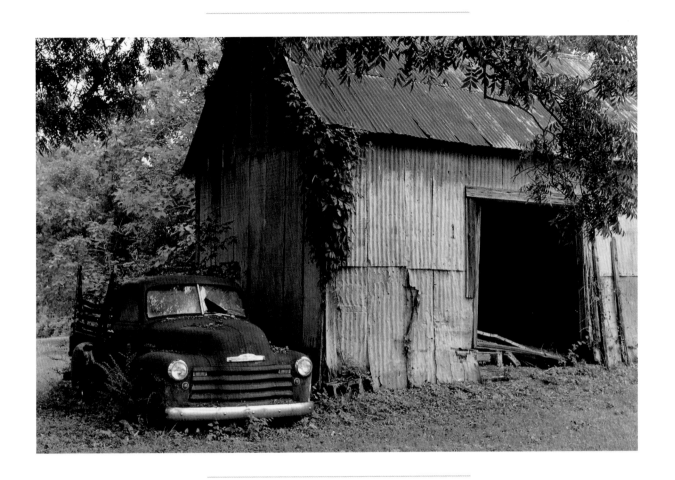

BURNT CORN

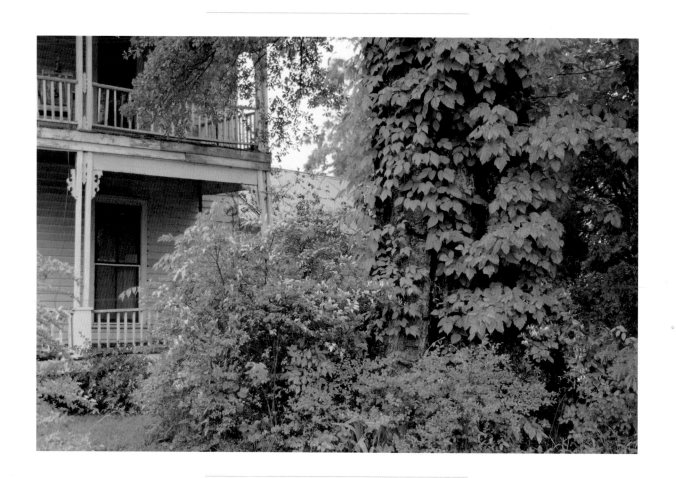

SOMERVILLE

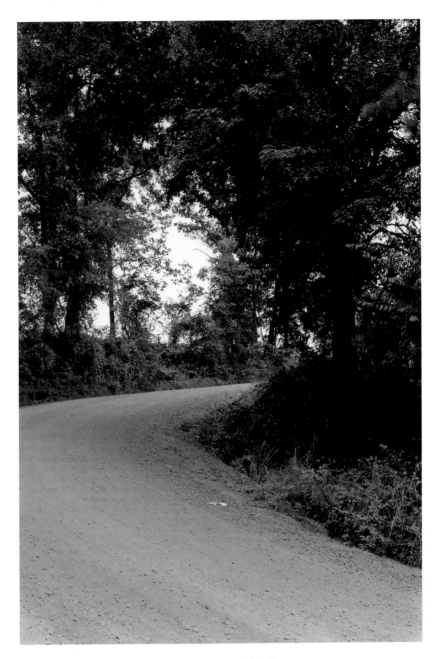

MONROEVILLE

I<small>T WAS A GOOD ENOUGH</small>
church from the moment the curve opened and we
saw it that I slowed a little and we kept our eyes on it.
But as we came even with it the light so held it that
it shocked us with its goodness straight through the
body, so that at the same instant we said *Jesus*.

—JAMES AGEE

Let Us Now Praise Famous Men

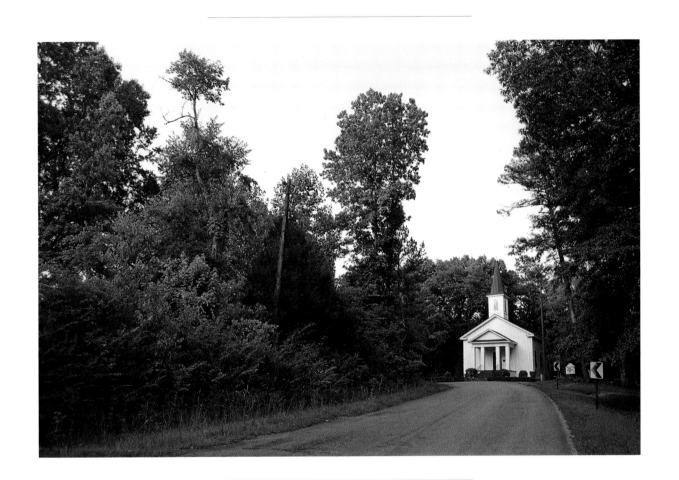

VERBENA

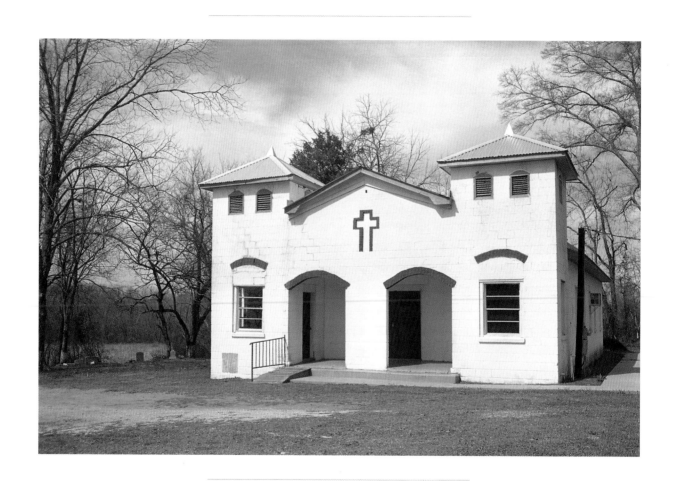

CATHERINE

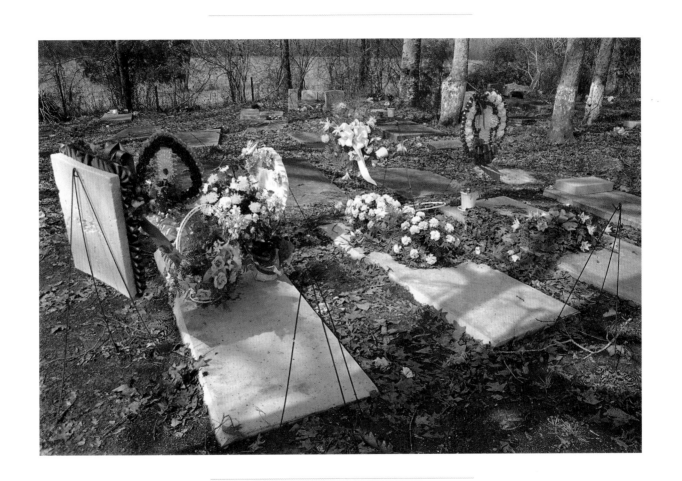

CATHERINE

DANIEL RAISED A PATCH OF what he called his martin-gourds every year and kept putting up more poles. Somehow or other he charmed them. . . . He said he loved the very hearts of purple martins and made them know it. He made them appreciate him as their friend, he said, but he gave all the credit to the Cherokees. Whenever you saw a martin at your house you could safely say, "There's one of Daniel's martins."

—HOWELL VINES
"The Ginseng Gatherers"

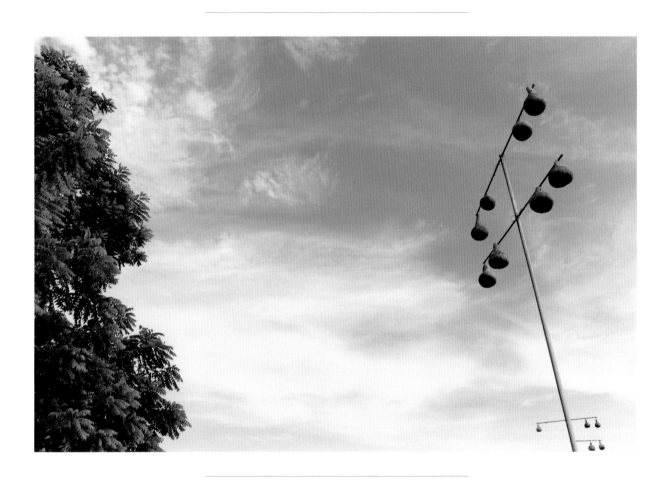

BRANCHVILLE

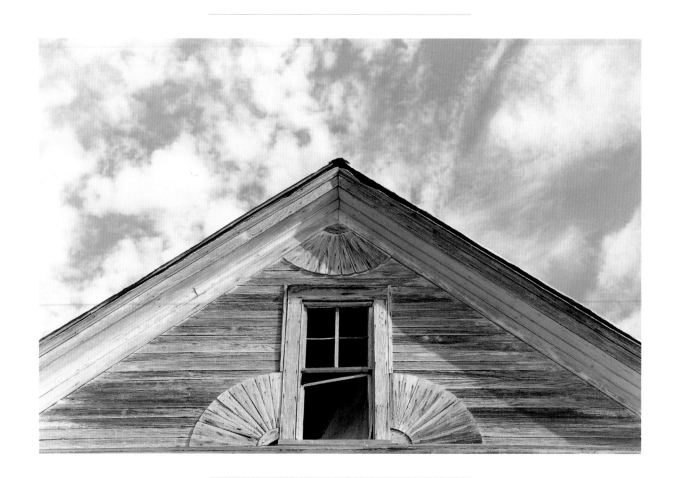

BRANCHVILLE

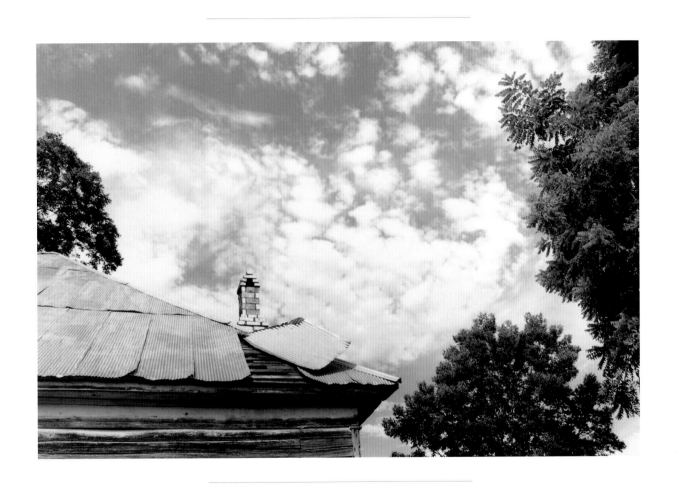

BRANCHVILLE

WE WOULD STOP AT A STORE in a tiny crossroads hamlet called Moseley's Bridge and he would buy me a Grapette, and he would talk about the weather or the world situation with the men gathered around the stove, chewing and spitting and laughing. Always laughing.

—WILLIAM COBB

"When the Opry was in Ryman and We Still Believed in God"

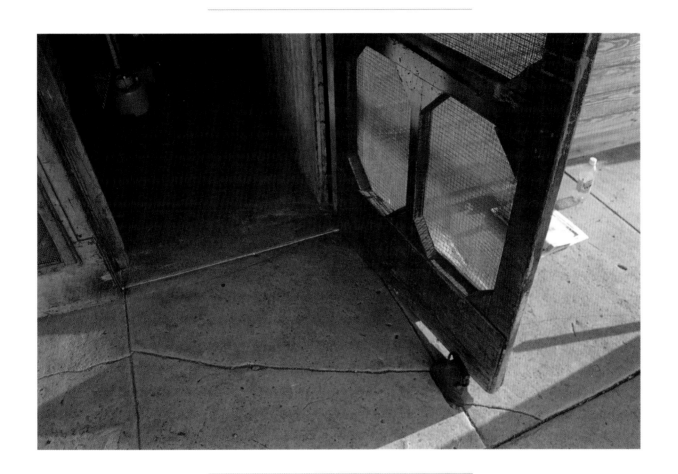

CHELSEA

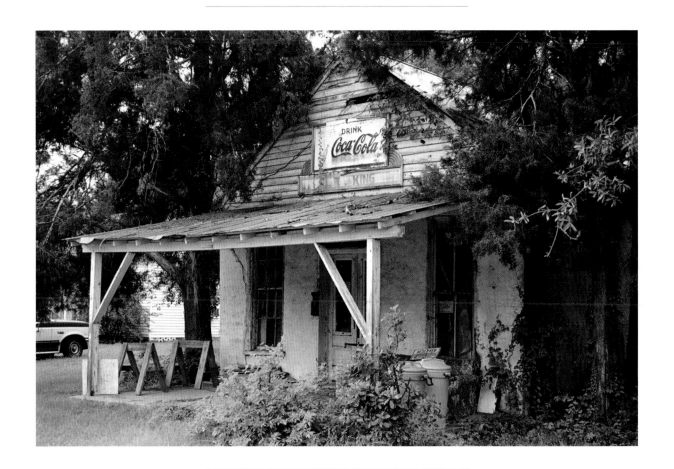

LINDEN

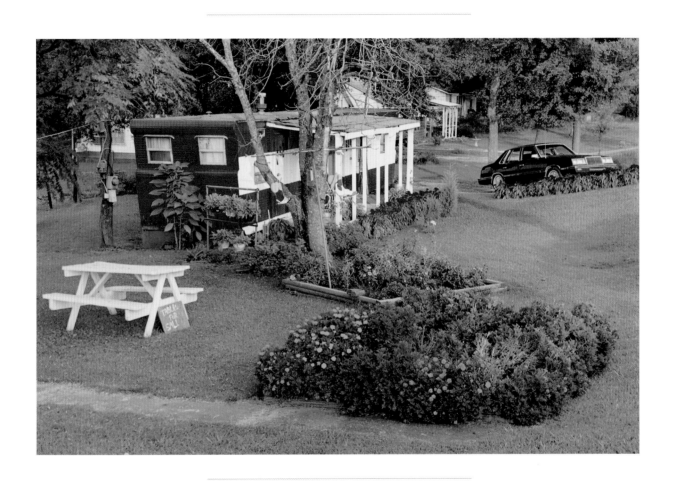

HARPERSVILLE

SKEETER WAS TOUCHING UP
Red Gilmore who ran Red's Varsity Threads Shop next
door and always came in on Tuesday, Thursday and
Saturday mornings to keep from looking as if he ever
needed to go to the barbershop.

—ALBERT MURRAY
"The Spyglass Tree"

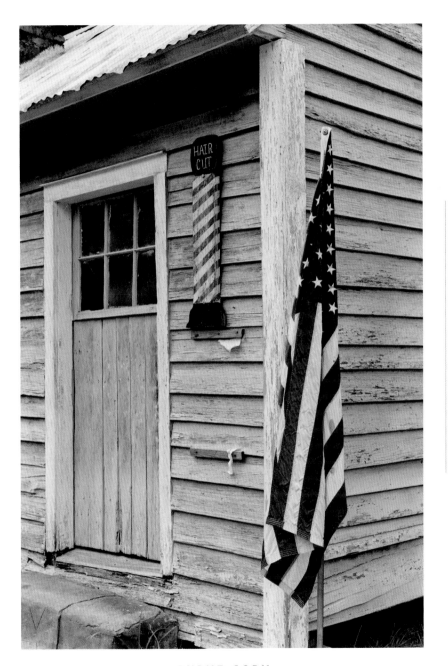

BURNT CORN

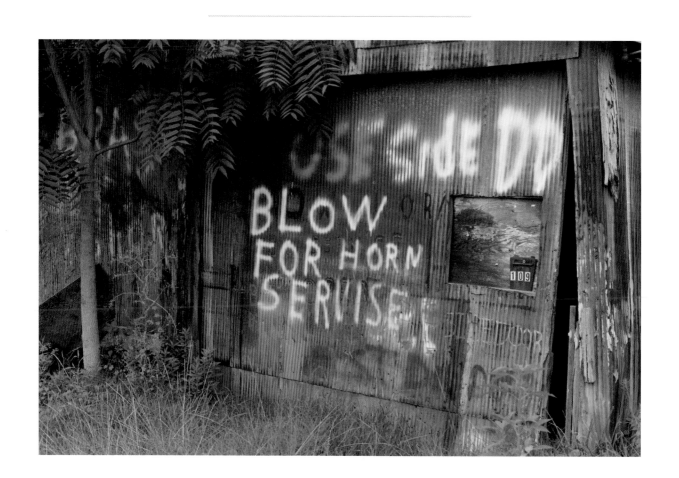

LEEDS

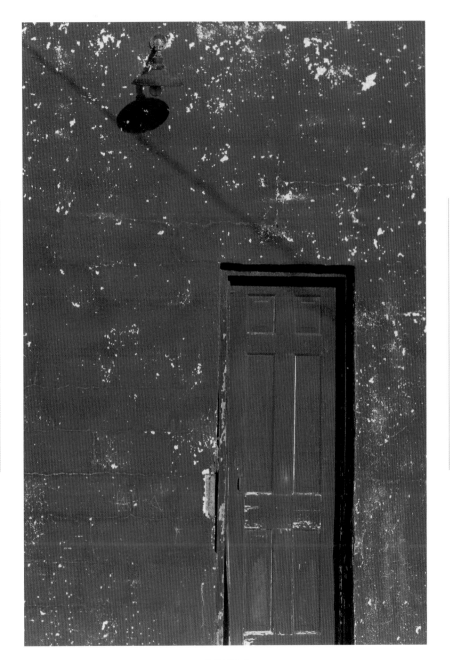

LEEDS

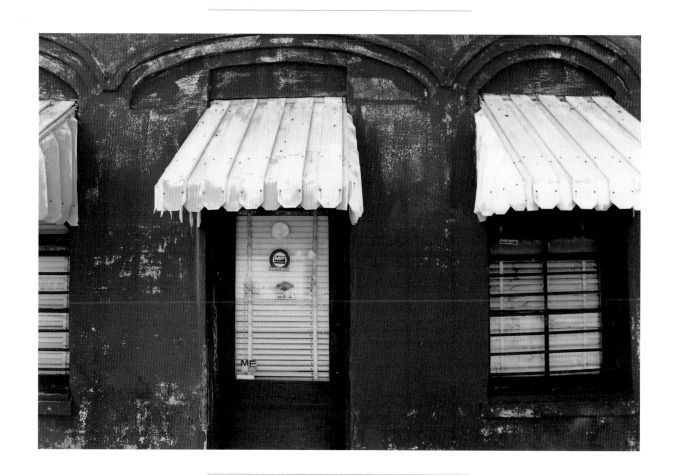

CLIO

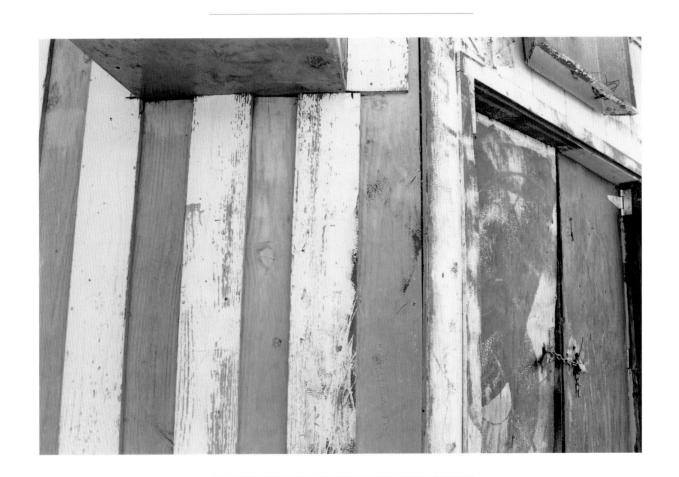

EUFAULA

INDUSTRY HAD A MOVIE theater and a Dairy Dog, a cottonseed mill, a Purina feed store, a John Deere dealer and a used-car lot and a couple of cafés, but not much in the way of industry. Dove explained that the town's name had been dreamed up during the Depression by some merchants who thought it might attract a factory or two, but so far it hadn't worked.

—MARK CHILDRESS
Crazy in Alabama

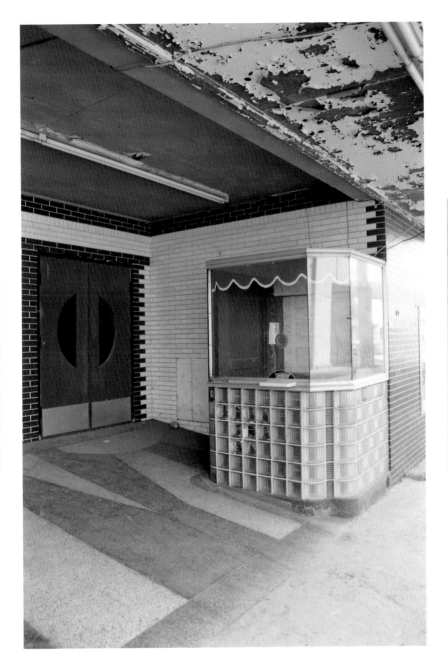

COLLINSVILLE

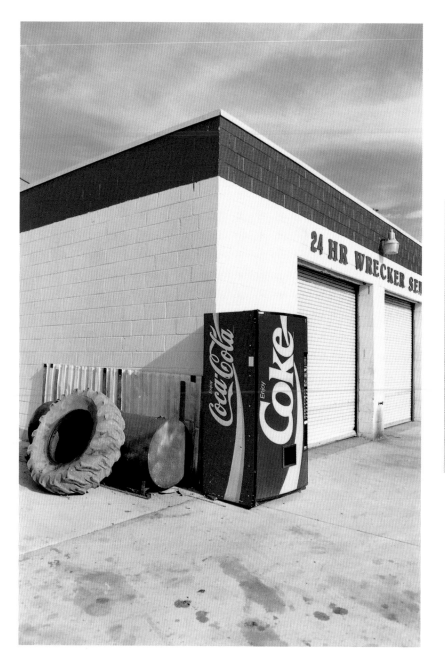

ASHVILLE

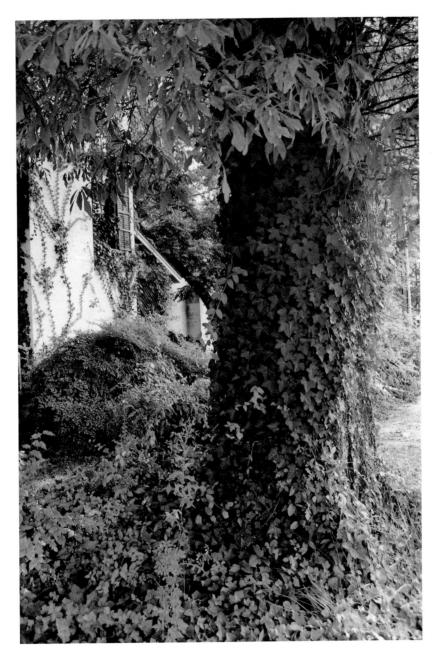

ASHVILLE

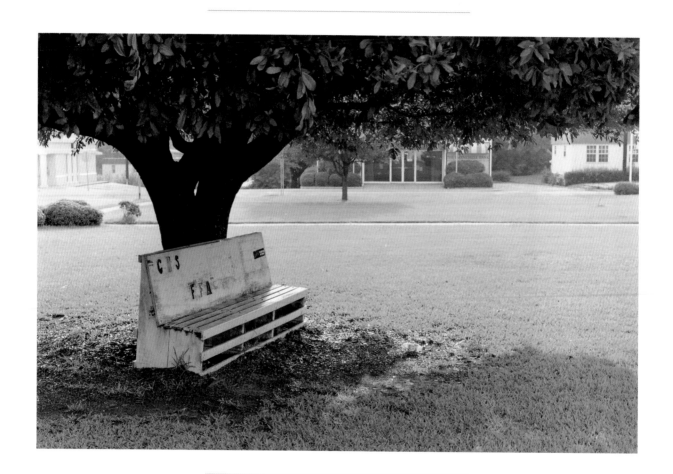

HAYNEVILLE

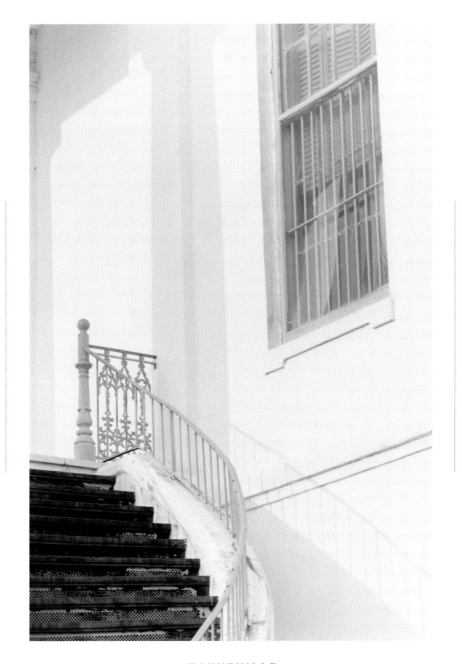

HAYNEVILLE

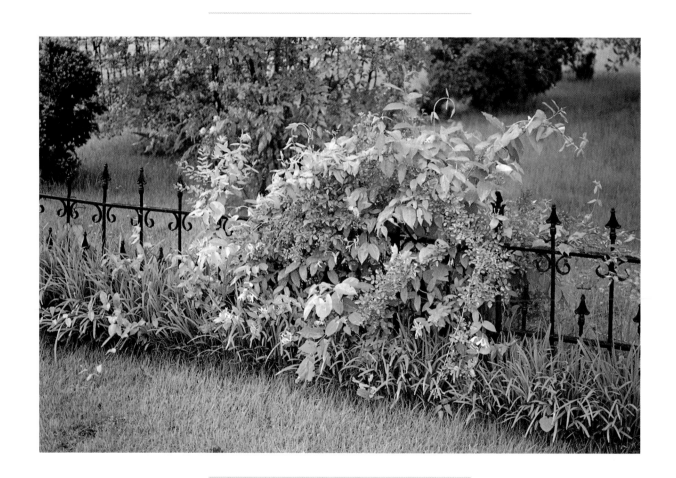

TUSCUMBIA

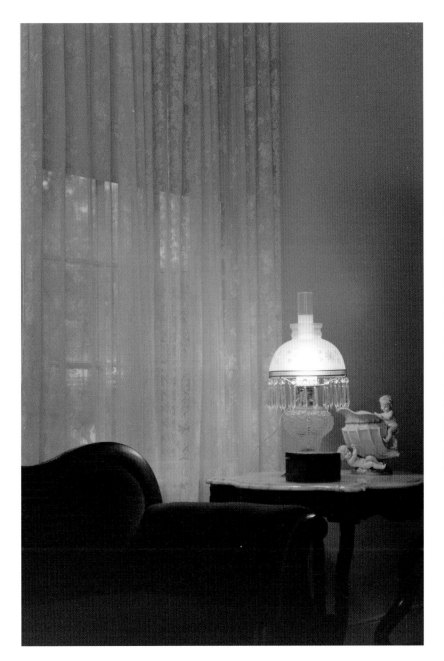

TUSCUMBIA

That there can be more beauty and more deep wonder in the standings and spacings of mute furnishings on a bare floor between the squaring bourns of walls than in any music ever made: that this square home, as it stands in unshadowed earth between the winding years of heaven, is, not to me but of itself, one among the serene and final, uncapturable beauties of existence.

—JAMES AGEE

Let Us Now Praise Famous Men

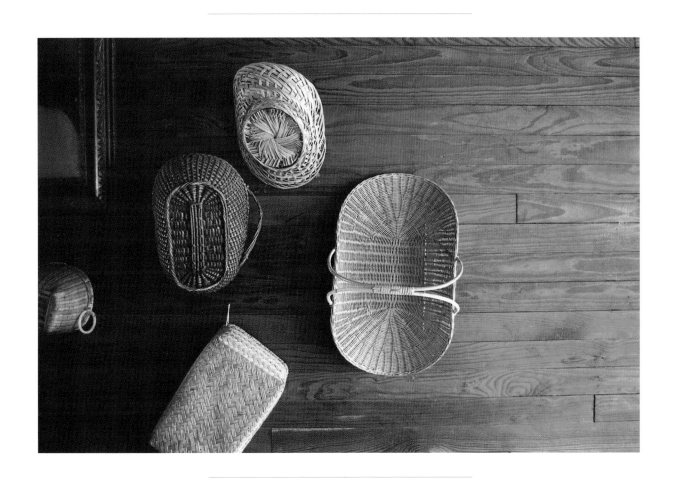

NEWBERN

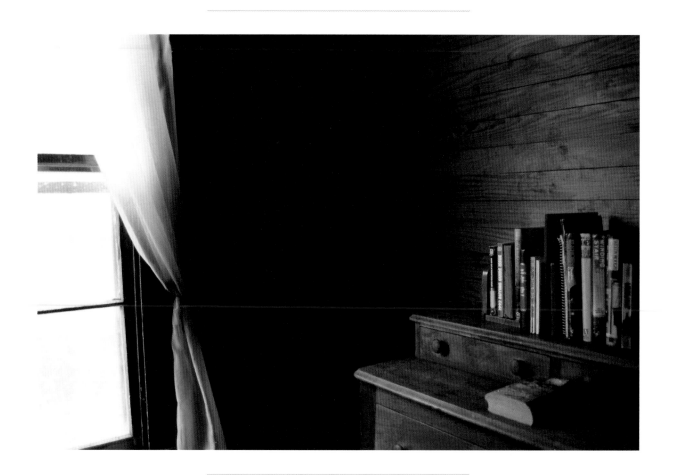

NEWBERN

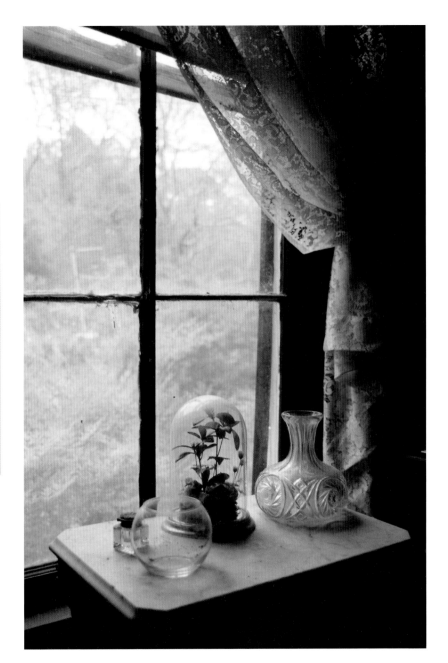

NEWBERN

Any preacher who came into our parts to preach always stayed at the Moss home. Mr. Arly would haul him to whatever church he'd been asked to preach. Pa said he told the preachers what to preach, or maybe it would be more correct to say he told them what not to preach. He didn't allow any talk about hell or money.

—NELL BRASHER
"Thunderbolts from Sinai"

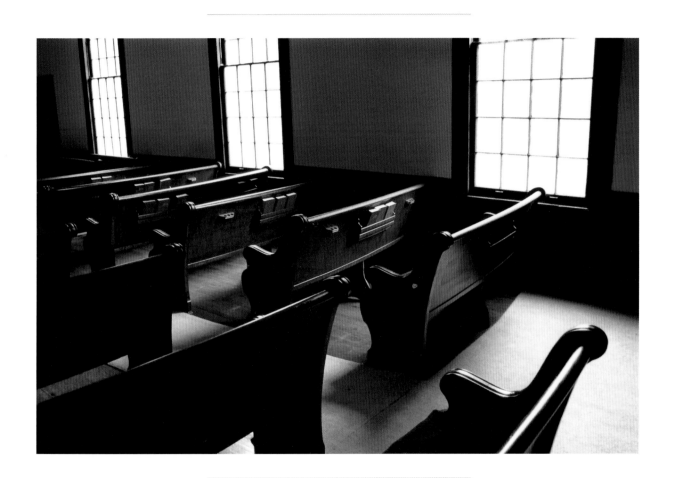

NEWBERN

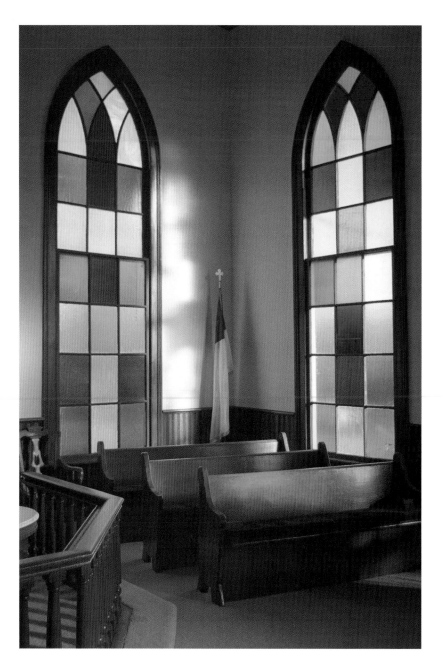

LOWNDESBORO

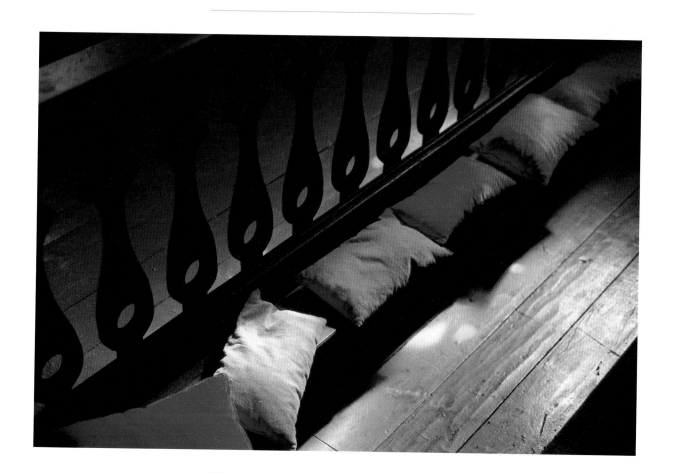

GAINESVILLE

HE DID NOT SEE A SINGLE white person in the town of Kilby; only the colored washerwomen hanging out clothes on fences and bushes. The white wives would be inside. He thought of them briefly: in their slips, lying on beds, with the shades drawn, fanning themselves slowly, waiting for the evening to come.

—SHIRLEY ANN GRAU
"White Girl, Fine Girl"

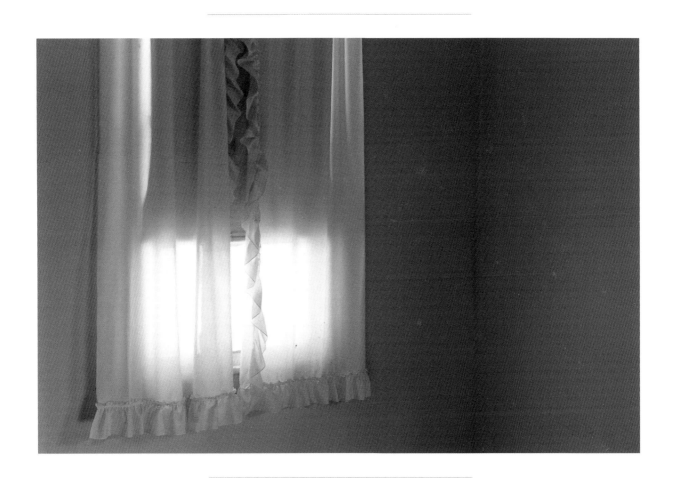

GAINESVILLE

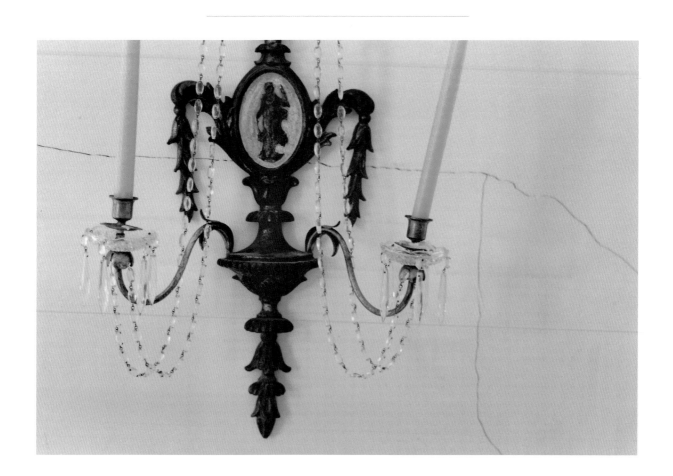

GAINESVILLE

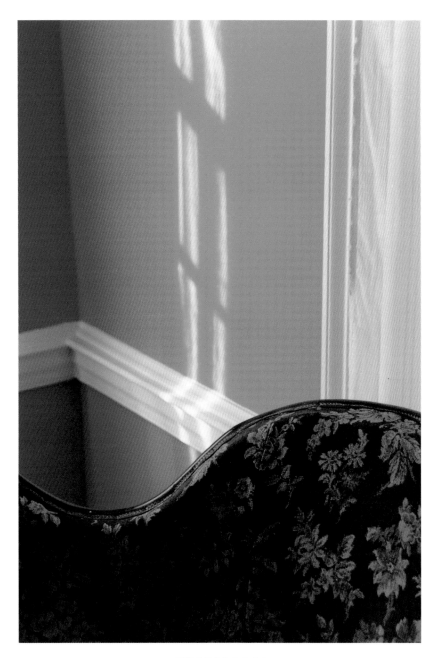

TUSCALOOSA

I FOLLOWED HIM INTO THE humid air of the old house. A narrow staircase led up to the third floor. The moment I topped those stairs I knew this was our special place, this vast attic room under the sloping roof at the way very top of the house. The air had a rich smell, like old books....

Wiley opened a grimy dormer window, and south Alabama spread out before us, green and rolling into the distance—rivers, clouds, houses, barns, the town, endless miles of trees.

—MARK CHILDRESS
Crazy in Alabama

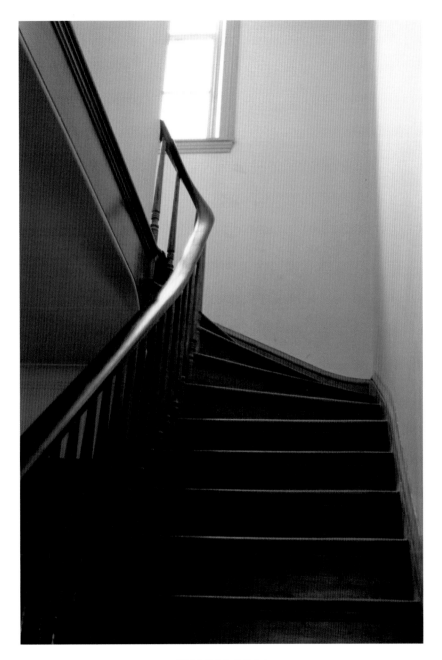

TUSCALOOSA

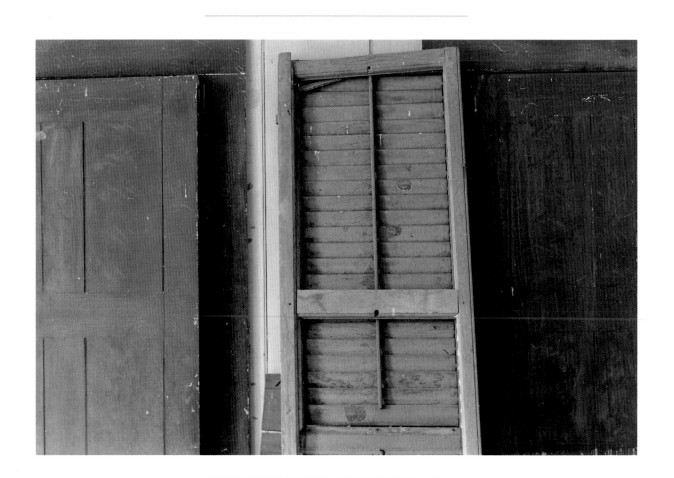

GAINESVILLE

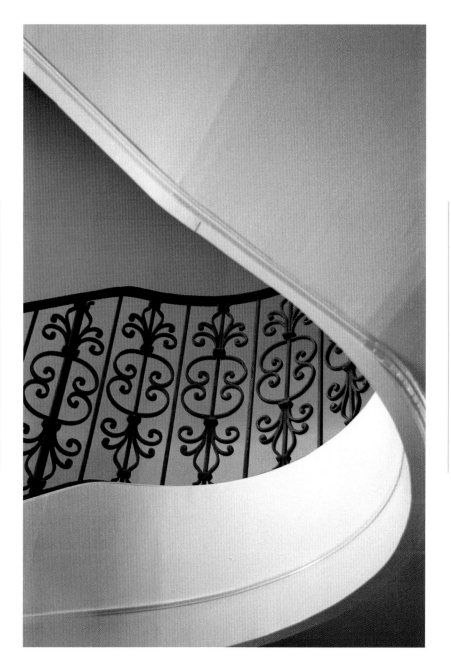

LOWNDESBORO

Hagedorn's, like Worthy's, had been family-owned for three generations. Lisa preferred Lowe's, which had a younger, newer clientele; but Mrs. Worthy did most of her shopping at Hagedorn's, and had for forty years.

—MARY WARD BROWN
"New Dresses"

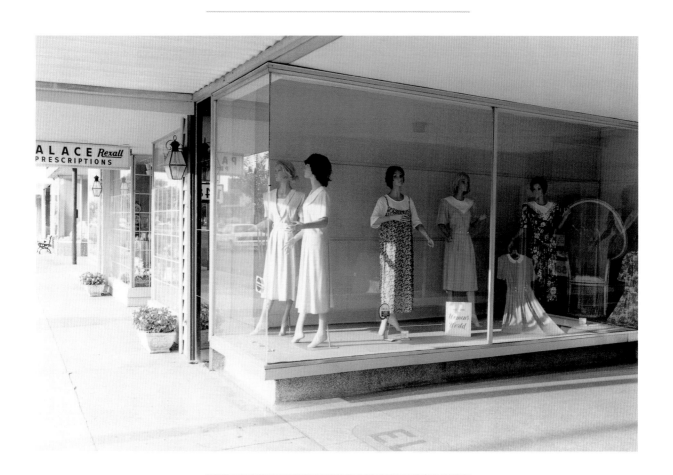

SYLACAUGA

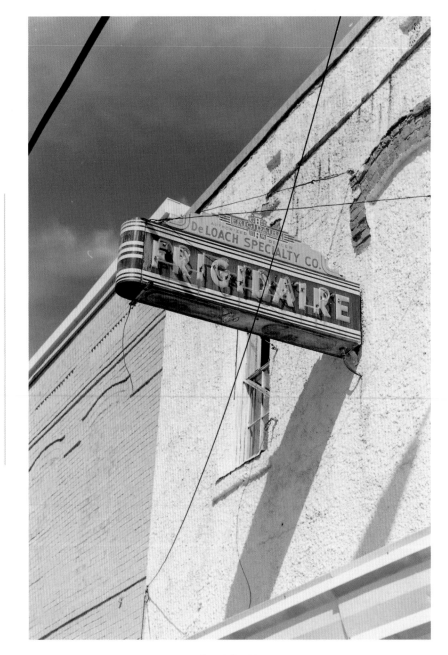

THOMASVILLE

THOMASVILLE

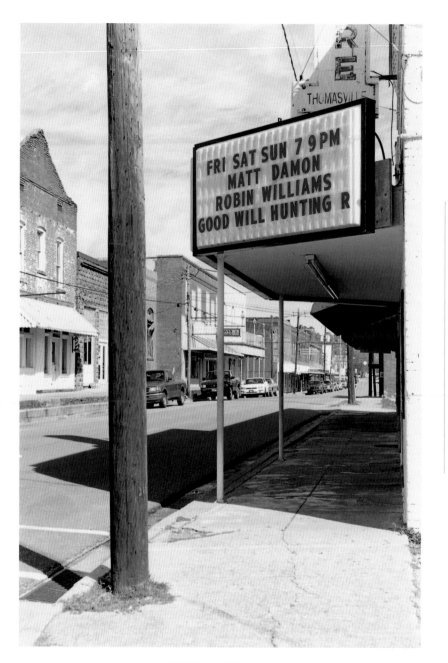

THOMASVILLE

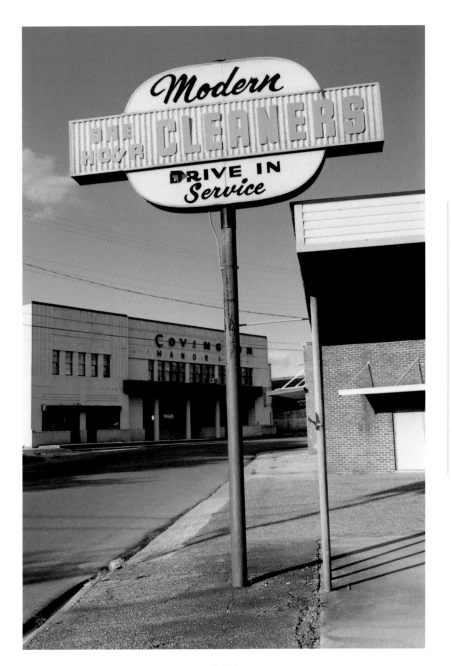

OPP

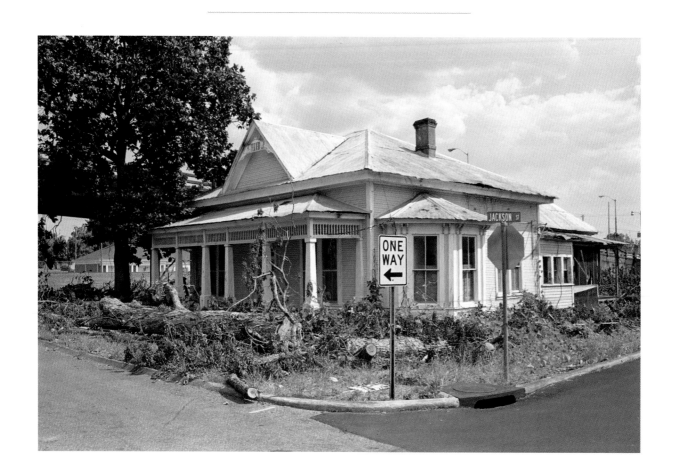

EVERGREEN

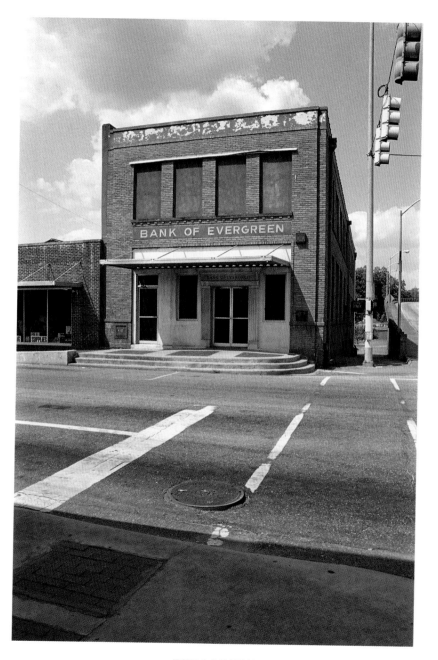

EVERGREEN

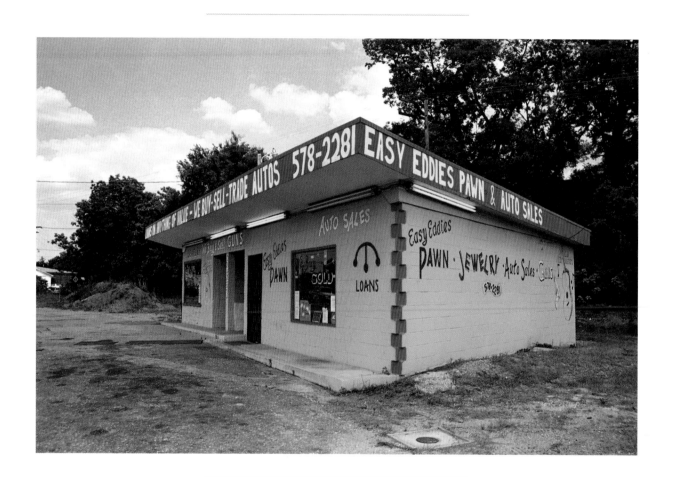

EVERGREEN

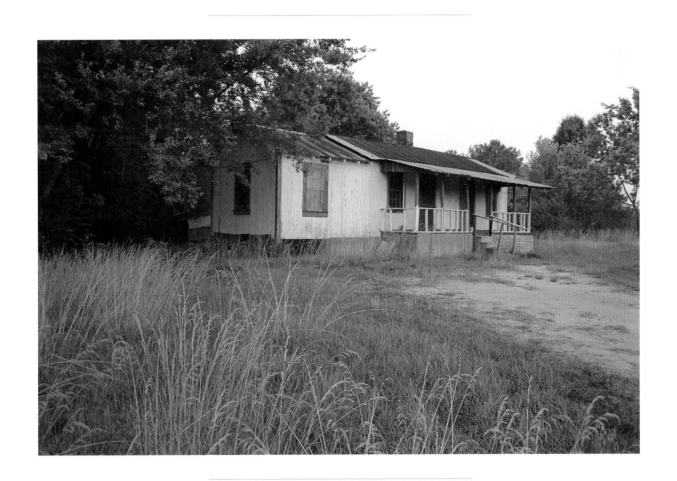

VERBENA

Now, AS A MATTER OF FACT, I have called in the Devil just recently. He is the only one who can help me get out of this town. Not that I live here, not exactly. I think always about somewhere else, somewhere else where everything is dancing, like people dancing in the streets, and everything is pretty, like children on their birthdays.

—TRUMAN CAPOTE
"Children on Their Birthdays"

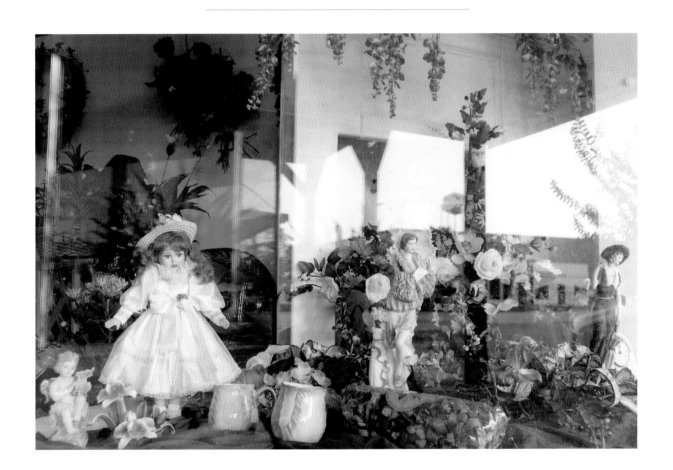

DADEVILLE

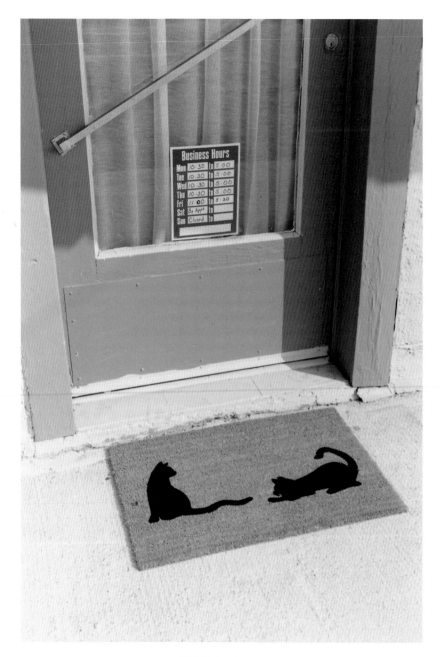

Business Hours

Mon	10:30	to	5:00
Tue	10:30	to	5:00
Wed	10:30	to	5:00
Thu	10:30	to	5:00
Fri	11:00	to	5:30
Sat	By Appt.	to	
Sun	Closed	to	

WETUMPKA

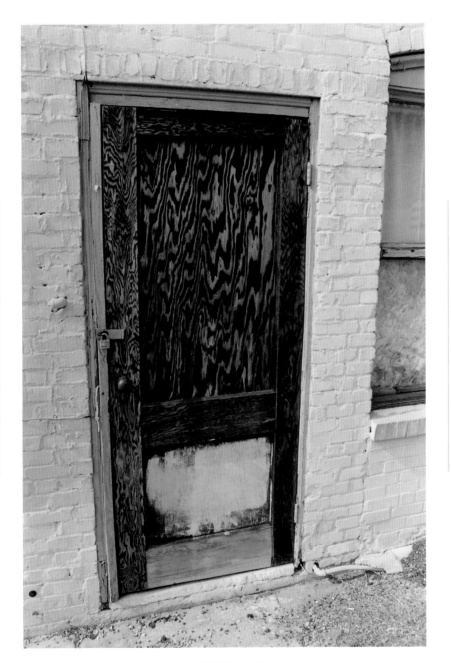

WETUMPKA

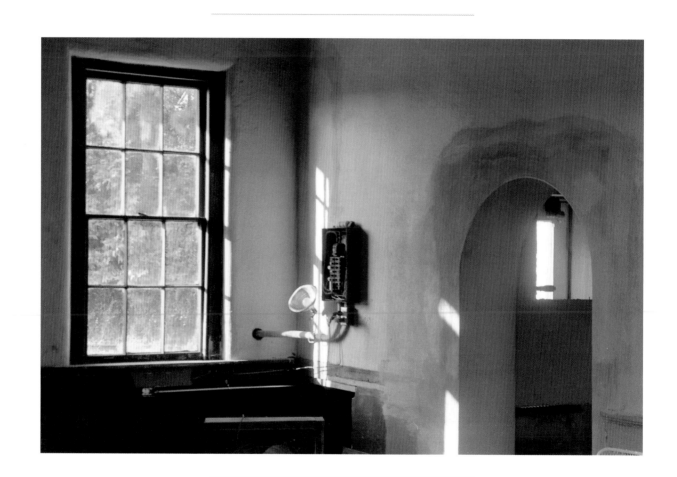

BRIDGEPORT

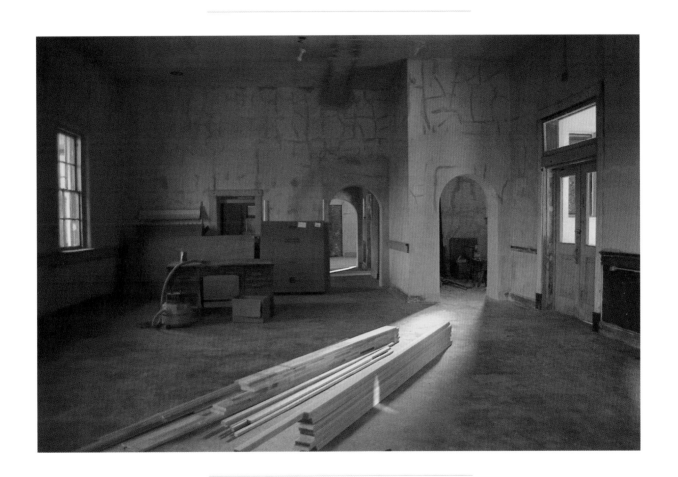

BRIDGEPORT

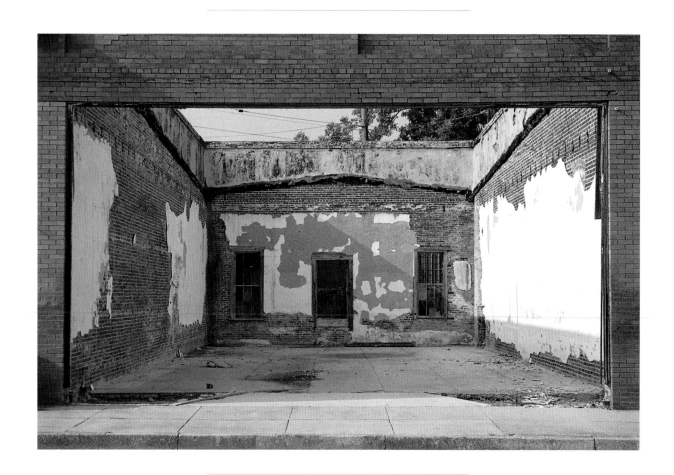

NOTASULGA

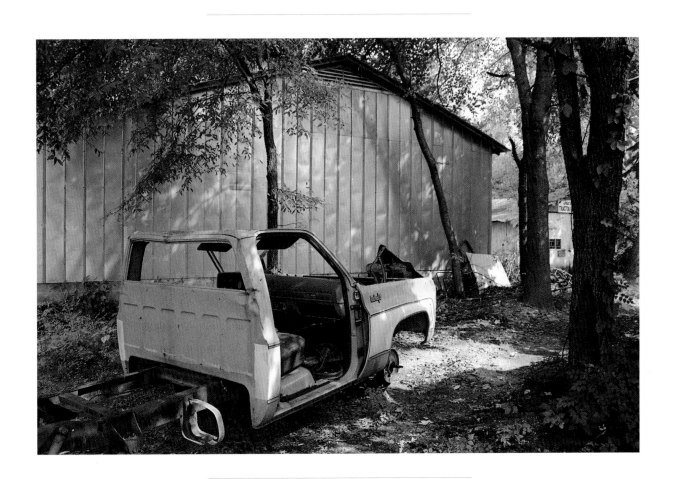

ECLECTIC

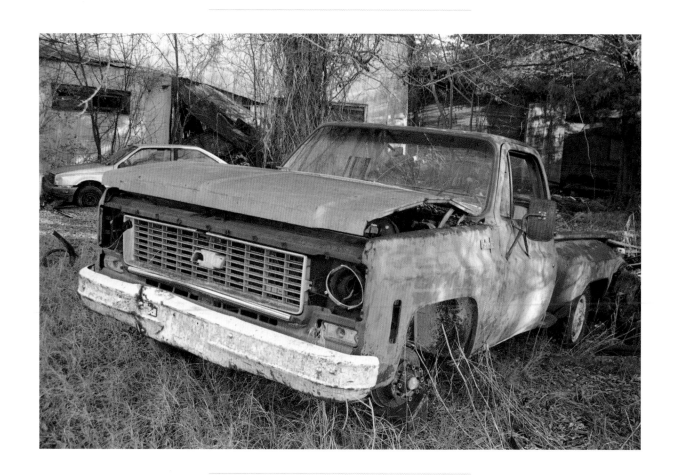

EPES

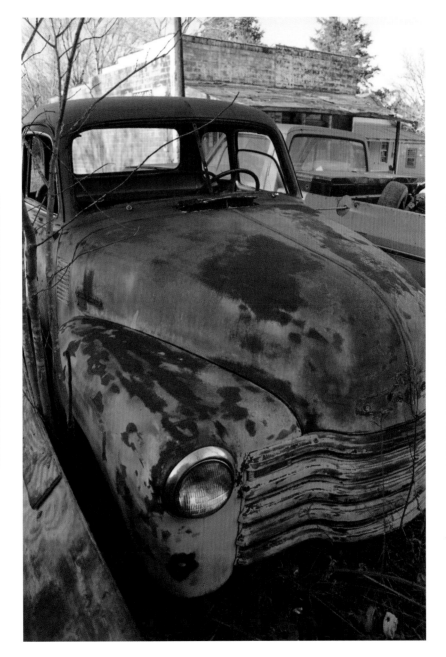

EPES

THESE WERE MISS ELLA'S hours of daytime rest. She never allowed herself to be disturbed until the sun had got well to the west and down behind the big house, its last light pulsing through the square hall-ways in the back windows and out the front, vivisected by the cold iron tracery of the upstairs balcony, to fall in shimmering splinters on the banana-shrubs below.

—ZELDA SAYRE FITZGERALD
"Miss Ella"

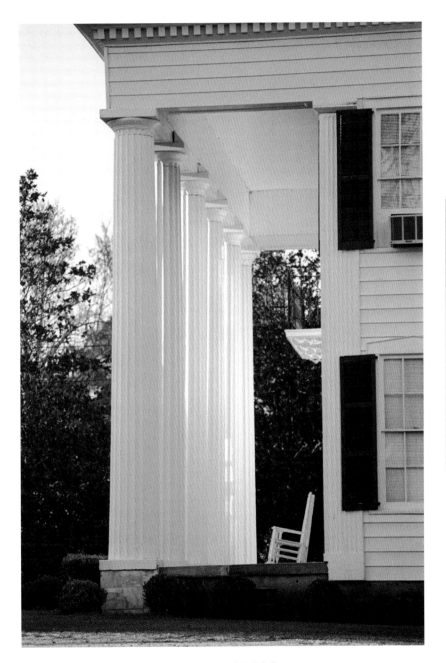

LOWNDESBORO

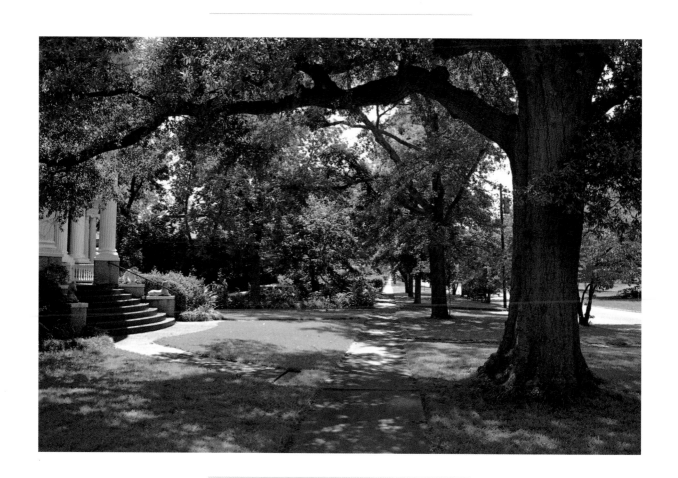

EUFAULA

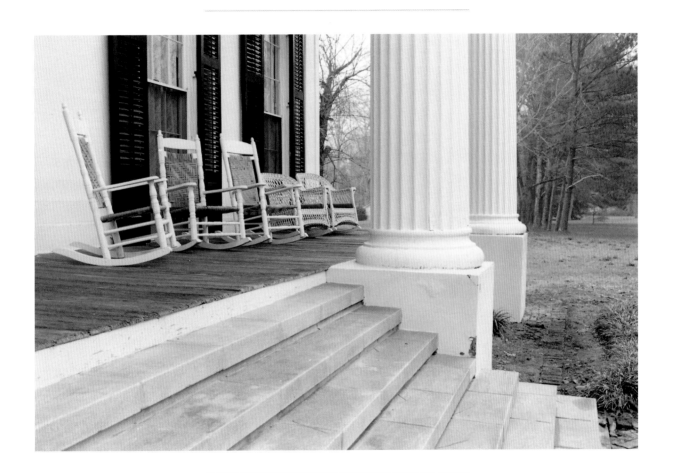

EUTAW

BOURNES AND DURVILLES,
De Graffenreids and Pettuses, and all the rest, they're
all gone … into an obscurity like hers, and she can't
follow them. Even the second best, the Stillsons over
in Camden and that sort that married money to save
themselves, she can't keep up with them, they don't
want to look at that old woman reminding them of
what they'd be if money hadn't saved their fine blood.

—HARRIET HASSELL
"History of the South"

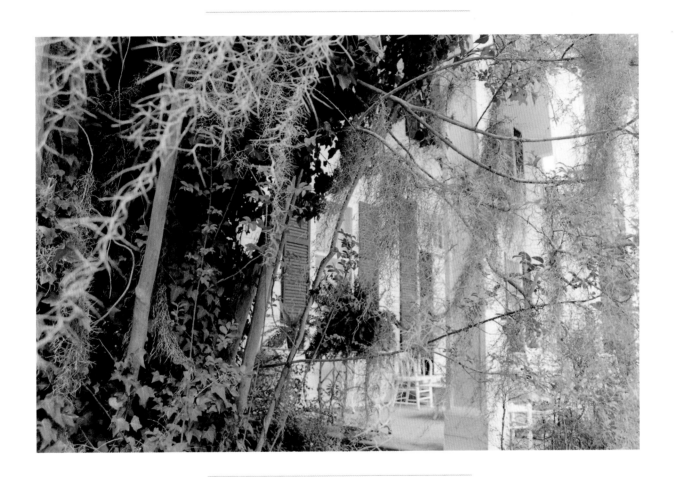

CAMDEN

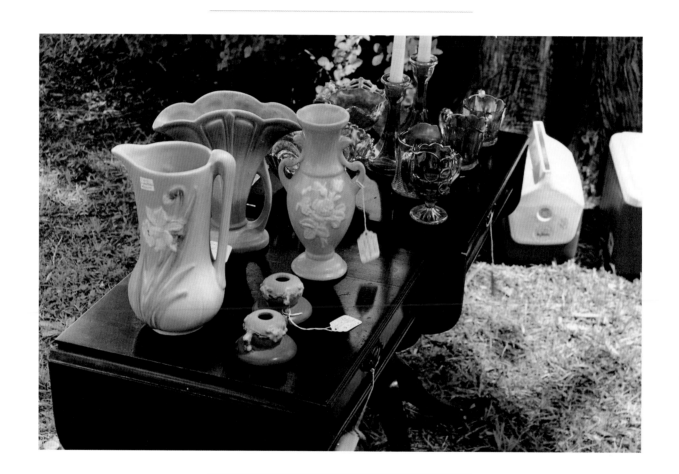

GAINESVILLE

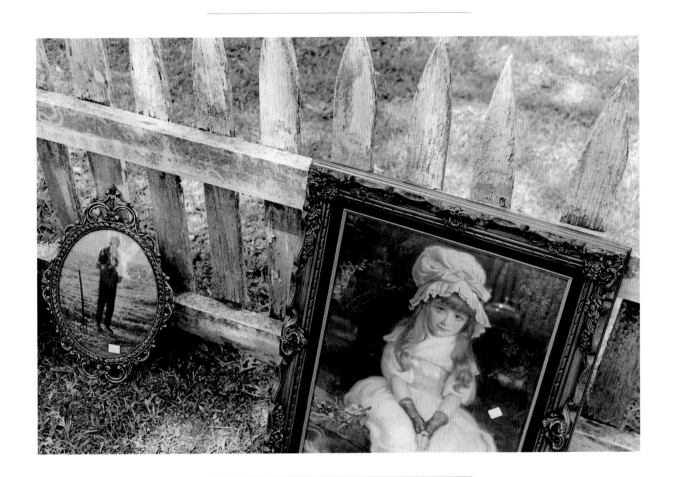

GAINESVILLE

SHE MOVED WITH THE GRACE of a devoted daughter, placing the linens just so, dusting the piano daily, displaying Mama's doilies and quilts with no apology rather than considering them old-fashioned and unworthy of show, wheeling Papa to the porch on summer evenings, and wearing that sweetheart bob into middle age, because it was something Papa liked.

—VICKI COVINGTON

Bird of Paradise

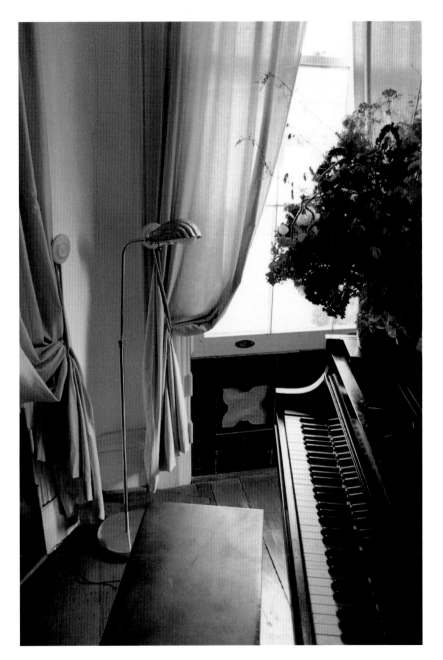

DEMOPOLIS

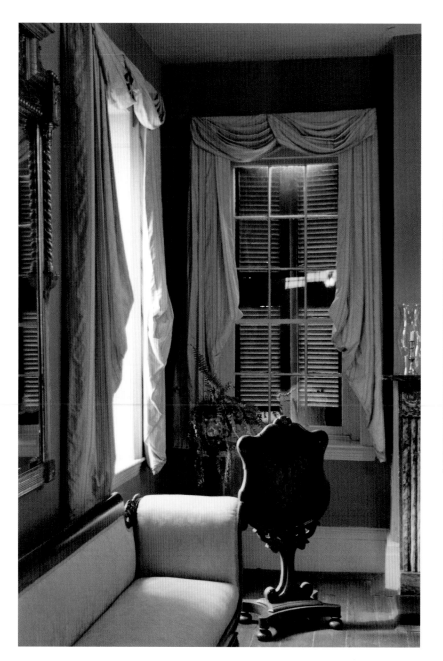

DEMOPOLIS

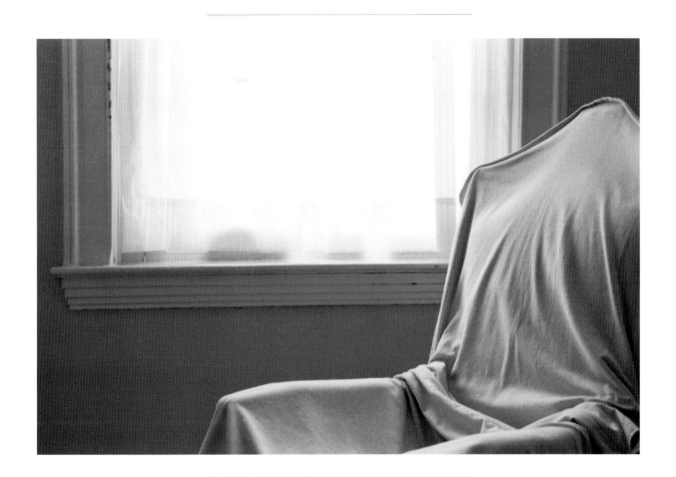

DEMOPOLIS

H{ER HUSBAND, J}OHNNY
Wingate, had died two years ago, leaving her the
legacy once left to him, a house built by his ancestors'
slaves. Sally was only fifty-three. In a sundress, her
shoulders tanned by the country club sun, she looked
younger; and with her features, she would be good-
looking twenty years from now. But there was no one
in Wakefield to marry her or even take her out. . . .
She was on the shelf here already, and she knew it.

—MARY WARD BROWN
"Let Him Live"

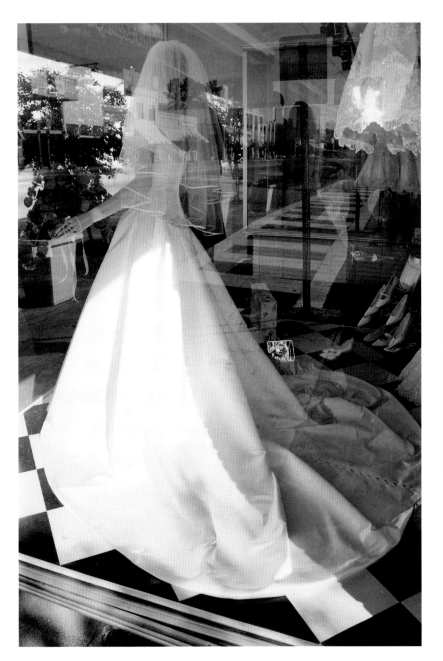

ENTERPRISE

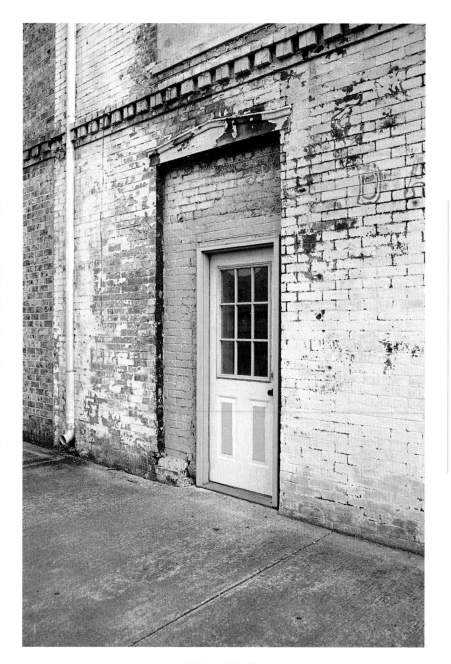

TALLADEGA

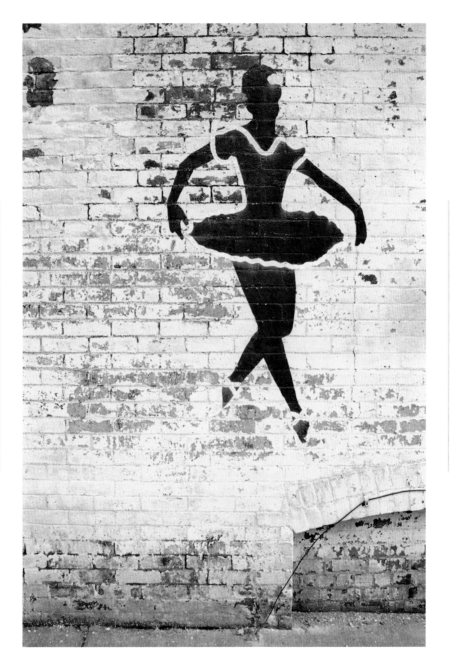

TALLADEGA

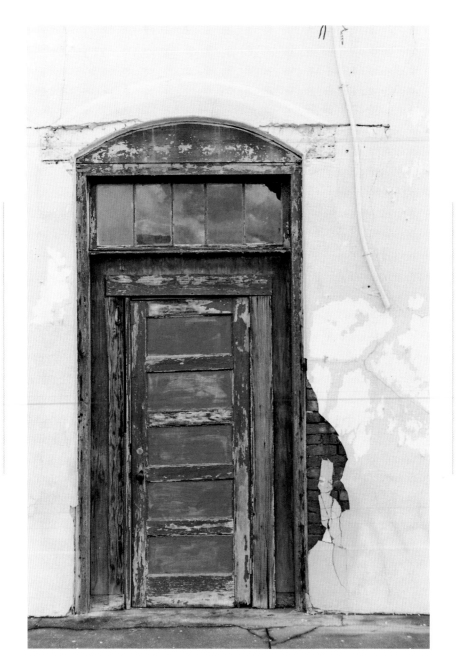

CLAYTON

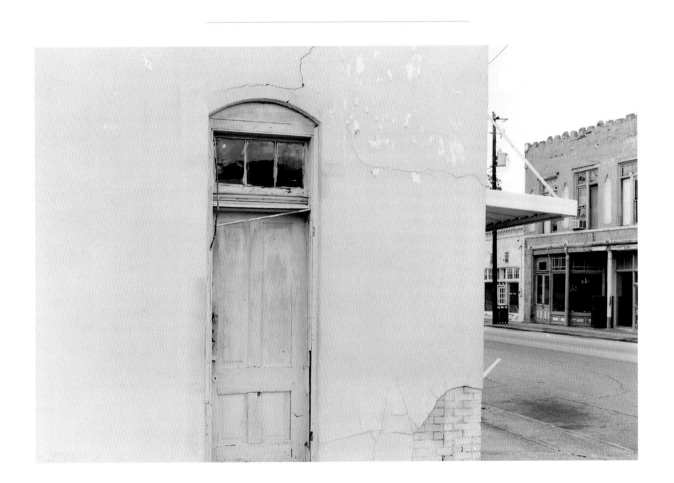

CLAYTON

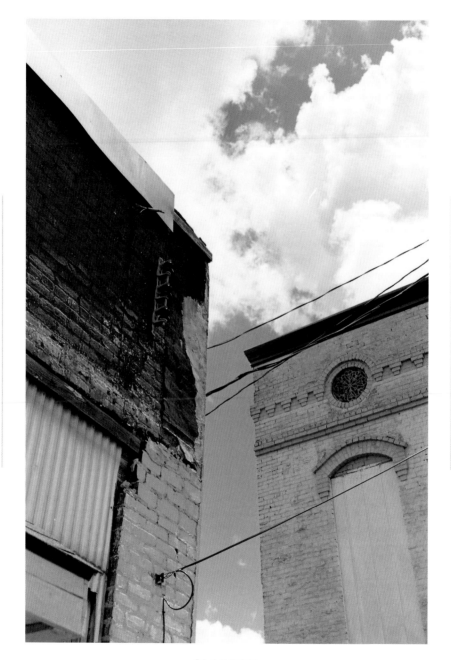

CLAYTON

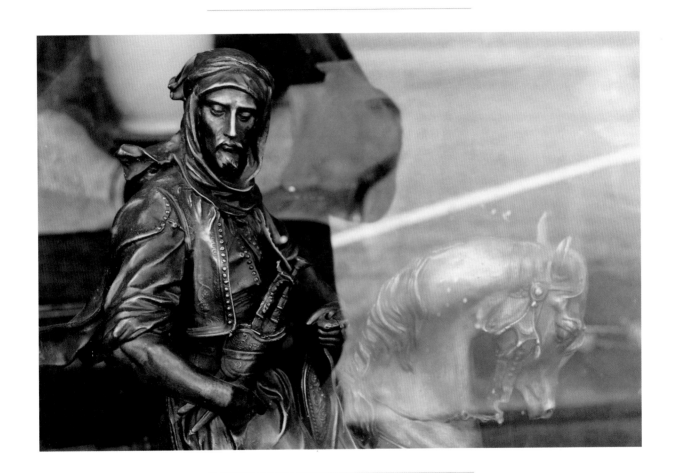

CLAYTON

A SOLDIER," HE SAID.

"A stone soldier?"

"Why that's right, Major Hammond," Sparks boomed. "That's right. A stone soldier, standin there guardin the town." And his finger pounded the drawings in his other hand. "Never thought of it like that, no sir."

And then the old man was crying, dry rasping sobs coming from deep inside his body, so that his head shook, and two tiny tears made a path across his leathery cheek.

—WILLIAM COBB
"The Stone Soldier"

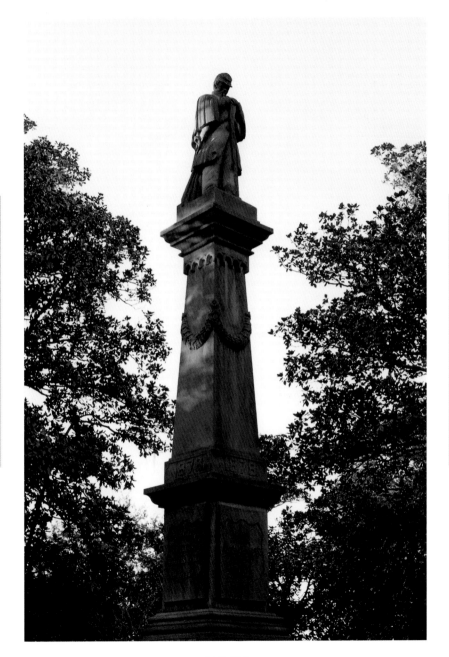

SELMA

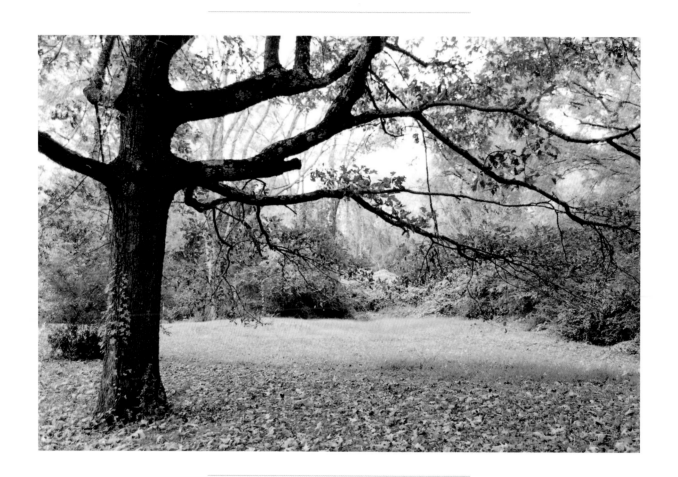

MOORESVILLE

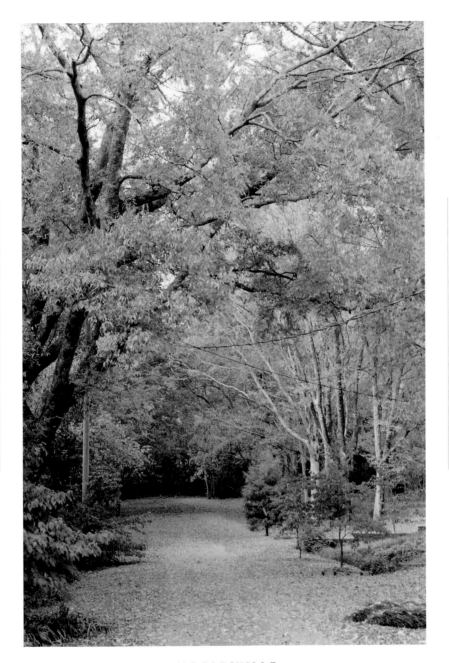

MOORESVILLE

S HE THINKING ABOUT
selling some stuff out the parlor."

Rose was holding the cup in her hand. She set it carefully back on the table by her bed. "What stuff?"

"Furniture. Mirrors."

Rose waited. "No silver?"

"Just furniture, far as I know, and big gold mirrors. Antique lady coming tomorrow. Not to buy, just look."

—MARY WARD BROWN
"It Wasn't All Dancing"

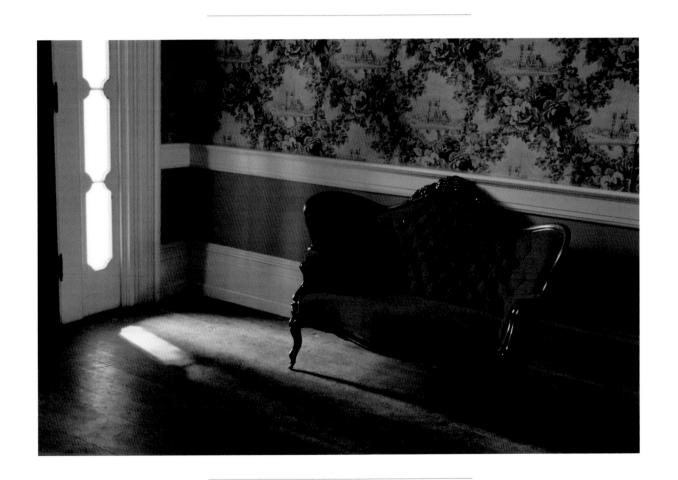

TUSCALOOSA

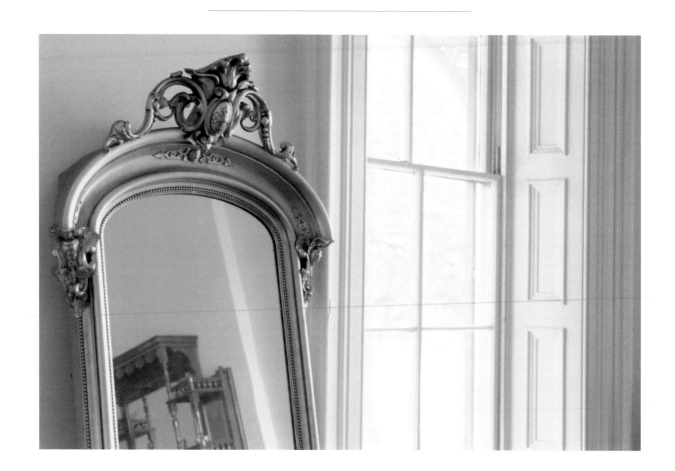

TUSCALOOSA

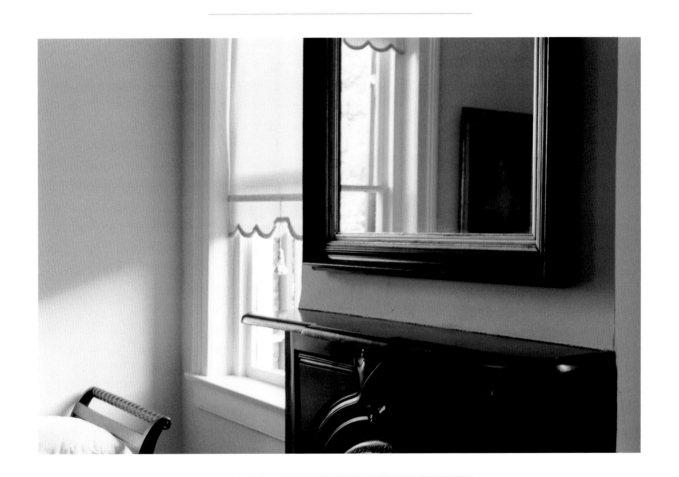

TUSCALOOSA

WHAT WAS THIS BUILDING used for in the past?" he said.

"It was a church, then a bank, then it was a restaurant and a fancy gambling house, and now *we* got it," Halley explained. "I think somebody said it used to be a jailhouse too."

—RALPH ELLISON
"The Golden Day"

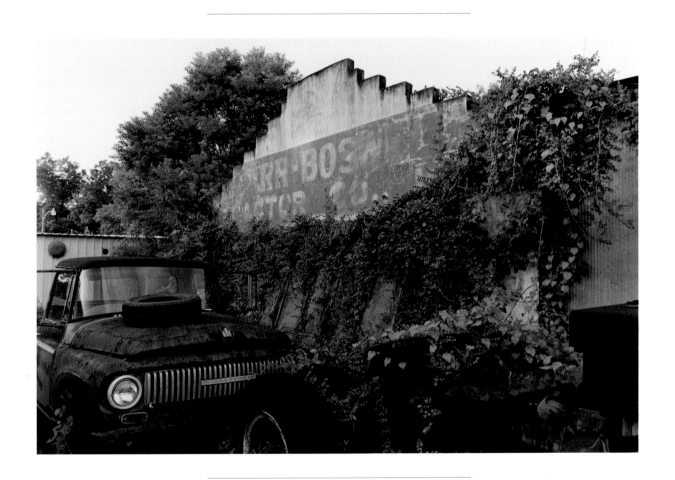

ROBERTSDALE

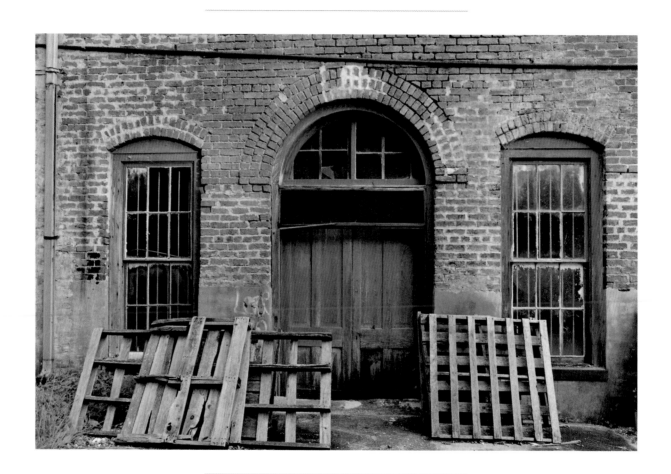

SPRINGVILLE

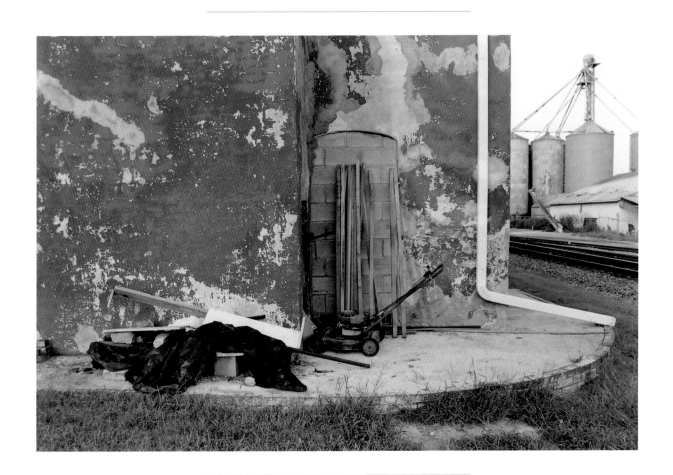

STEVENSON

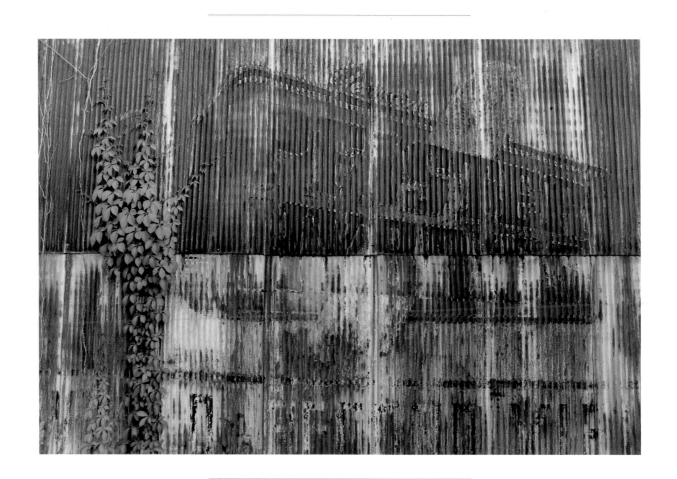

WINFIELD

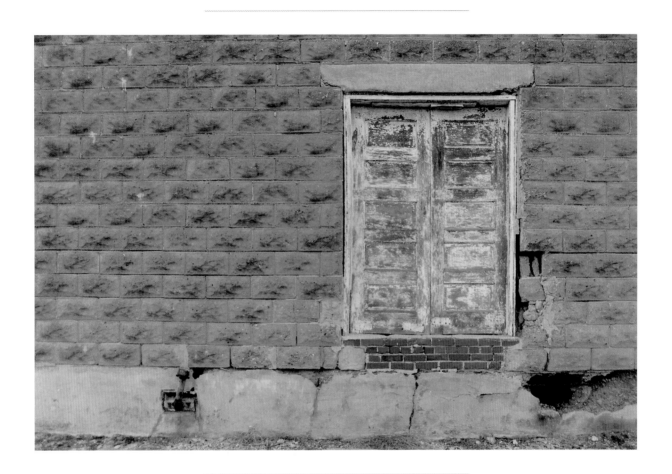

WINFIELD

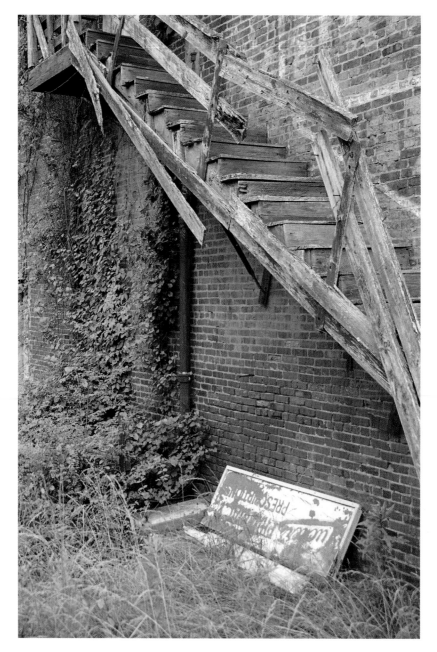

CAMP HILL

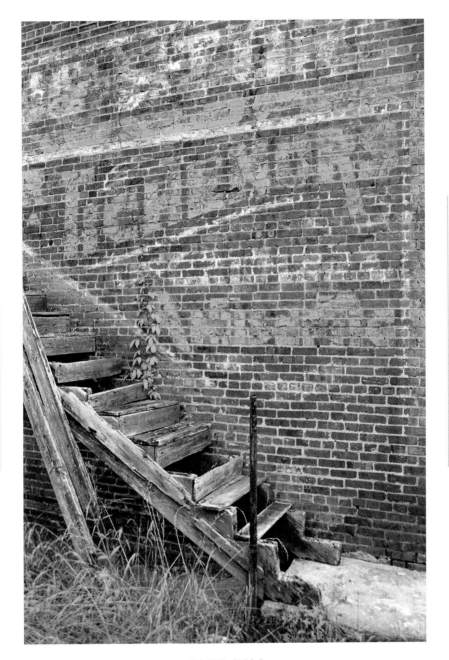

CAMP HILL

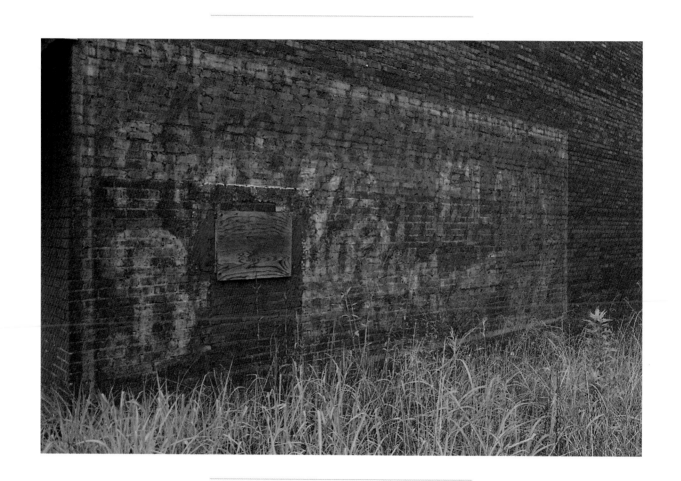

CAMP HILL

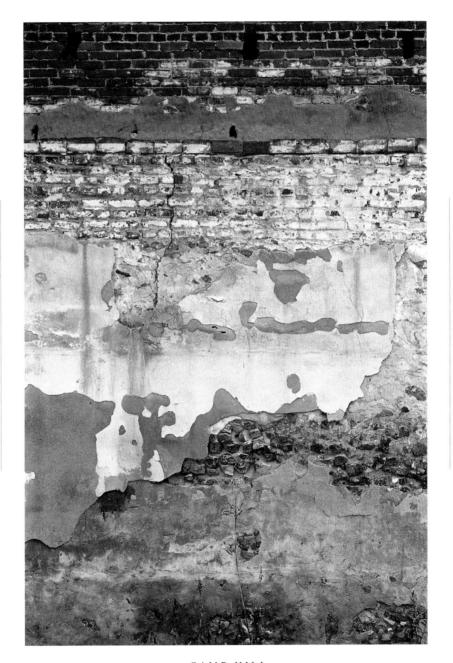

CAMP HILL

AND UP THE ROAD WAS
the old homestead, zoned commercial, destined, I
supposed, to be a bank or a children's-clothing
outlet—those were popular things now to be housed
in old homes, or perhaps an antique store. "Could be
somebody'll just buy it and tear it down," I said.

—VICKI COVINGTON

Bird of Paradise

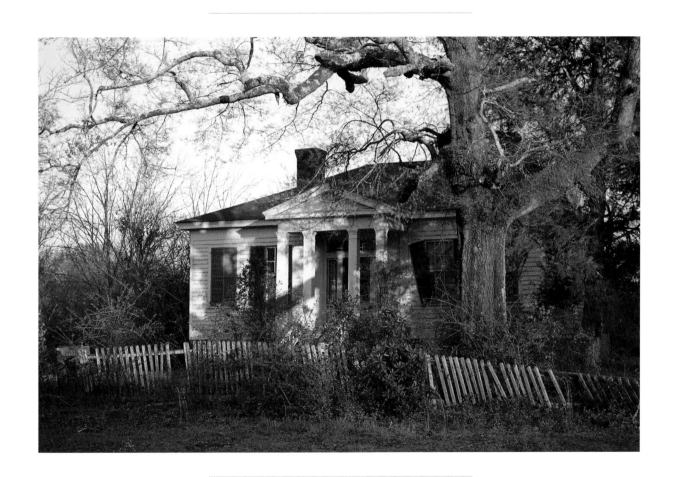

LOWNDESBORO

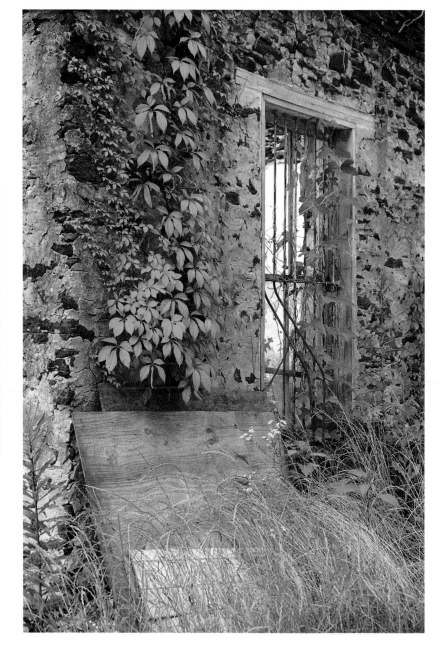

WAVERLY

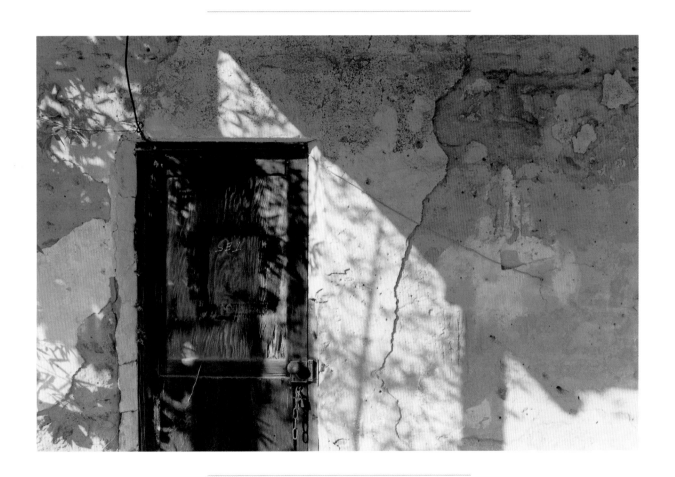

KELLYTON

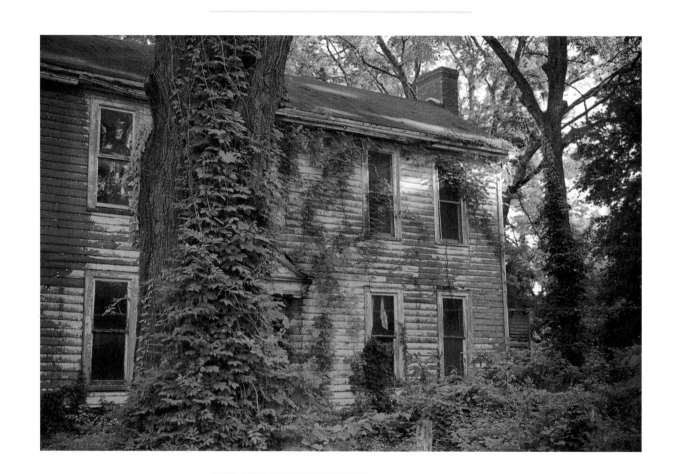

COURTLAND

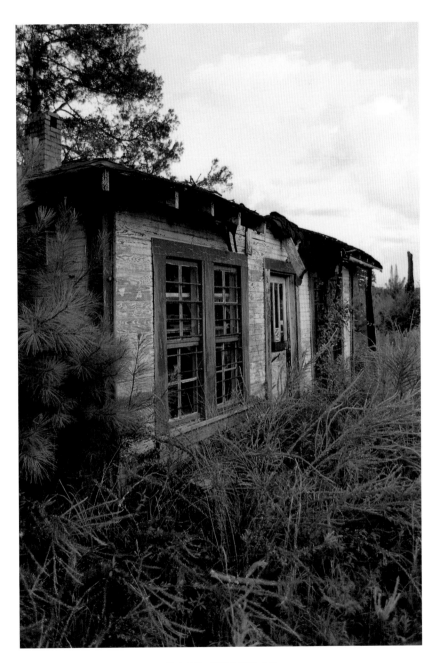

EAST CHAPMAN

I F YOU EVER NEED ANYTHING, here all alone, you call us, Judge Manderville," she said. "Day or night."

"I may have to do that," he said. "And I won't forget. Thank you."

"I see your light at night through the trees, and I think of you often," she said. "Your wife was lovely."

Suddenly, to his great surprise, his eyes filled with tears and so, he saw, did hers.

—MARY WARD BROWN
"The Amaryllis"

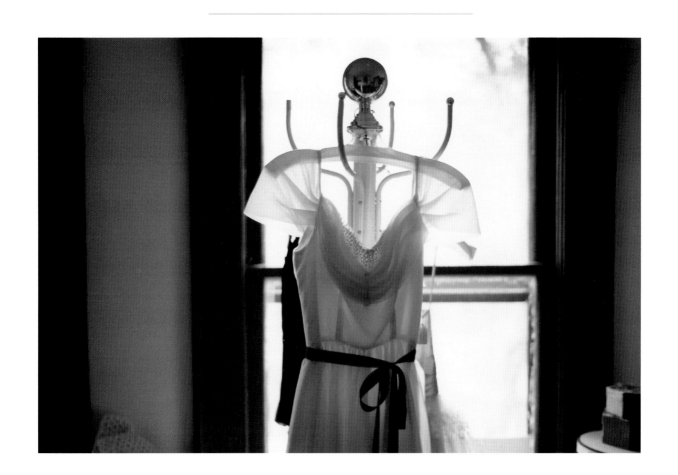

MENTONE

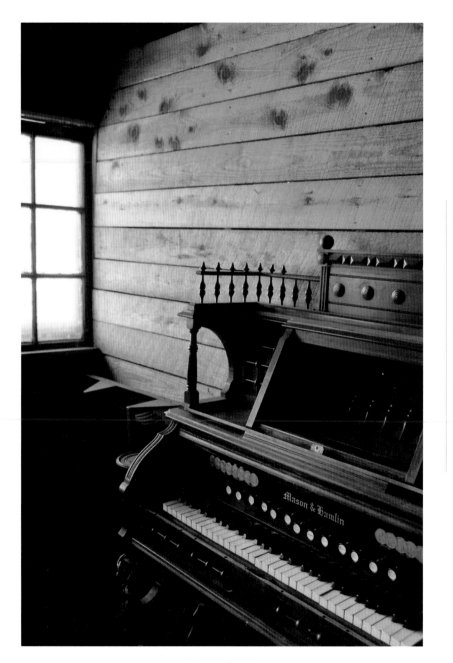

MENTONE

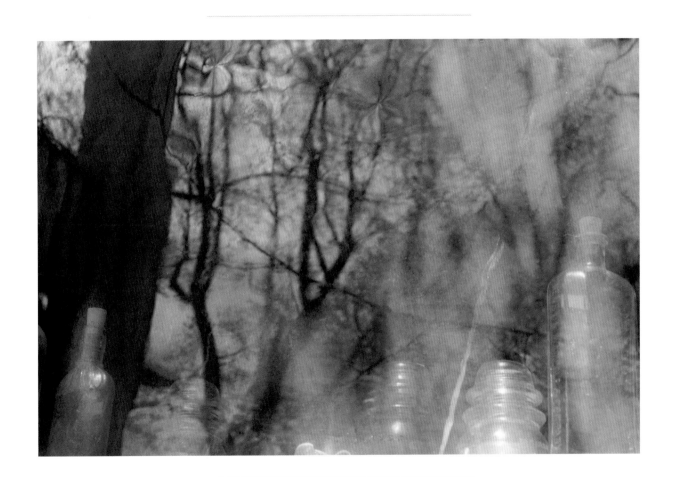

MENTONE

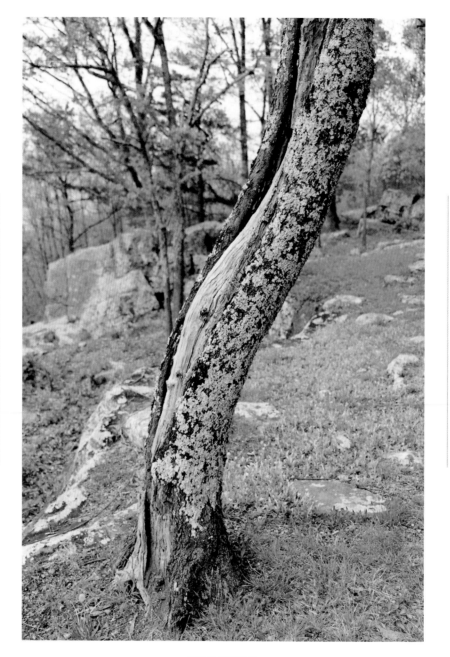

MENTONE

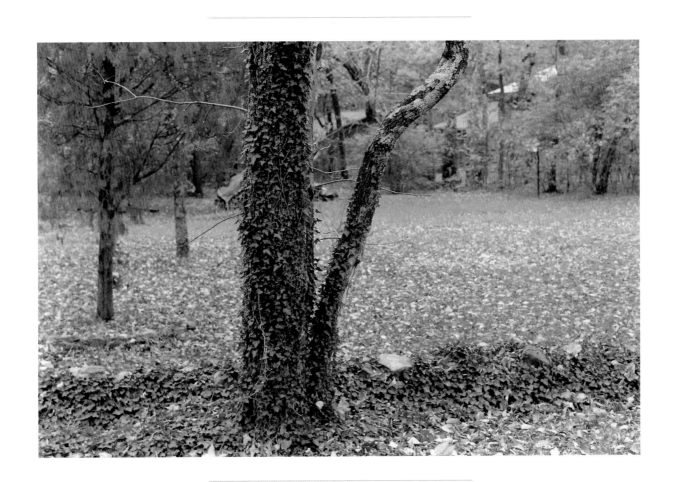

MENTONE

FROM EARLY CHILDHOOD
Beryl had listened so intently to her mother's glowing
descriptions of the beauty and elegance of her old
home "Elm Bluff," that she soon began to identify the
land-marks along the road, after passing the cemetery,
where so many generations of Darringtons slept in
one corner, enclosed in a lofty iron railing; exclusive
in death as in life; jealously guarded and locked from
contact with the surrounding dwellers in "God's Acre."

—AUGUSTA EVANS WILSON
"The Old General and the Lost Granddaughter"

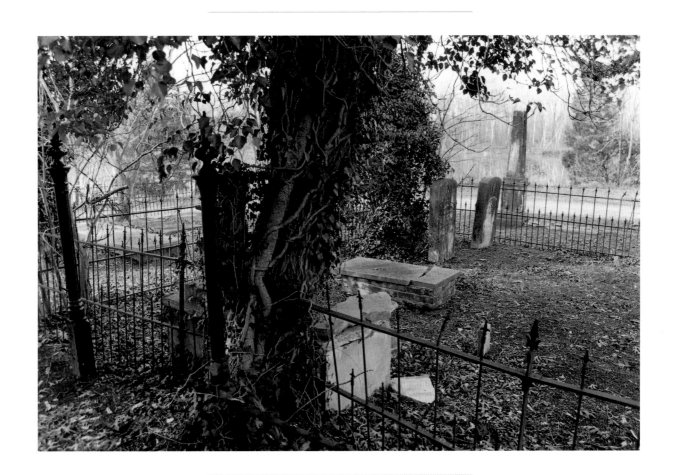

DEMOPOLIS

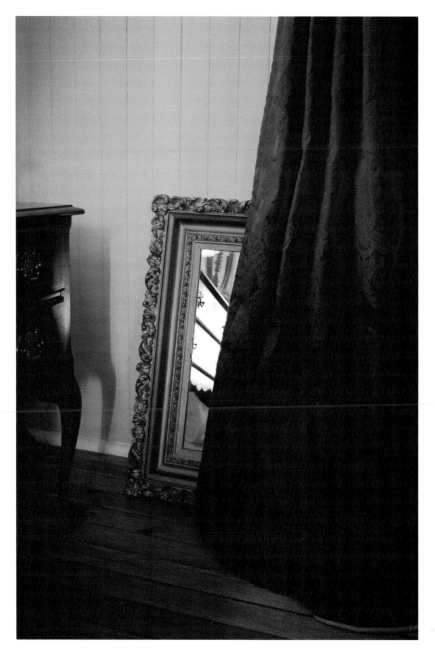

VALLEY HEAD

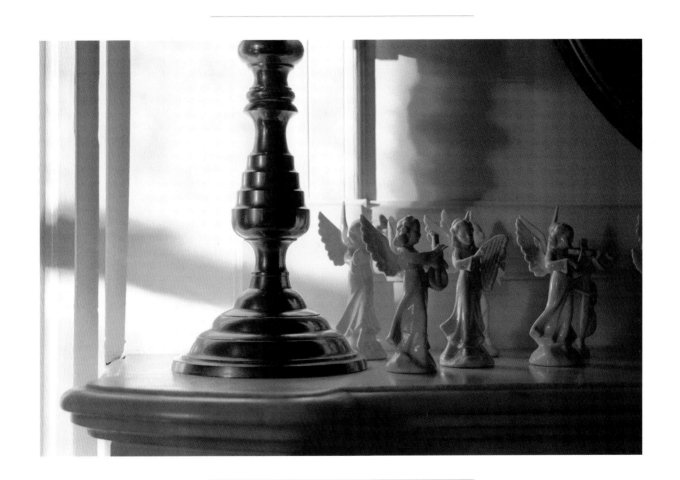

VALLEY HEAD

WHEN DEATH VISITS OUR little town, each one left knows that he is diminished, by little or much. No man here is a nobody. Everybody is a somebody. And the sadness at death is genuine. What is more, long memories hold the departed in mind and heart. The vacant church pew, the missing face, the voice, the laughter—the good and not-so-good are remembered and missed.

—VIOLA GOODE LIDDELL

A Place of Springs

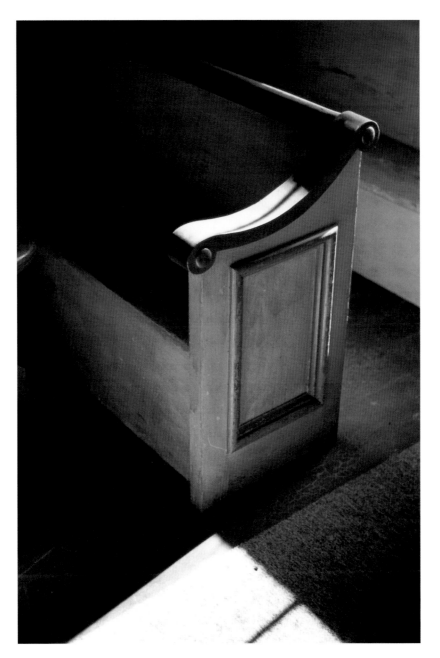

GAINESVILLE

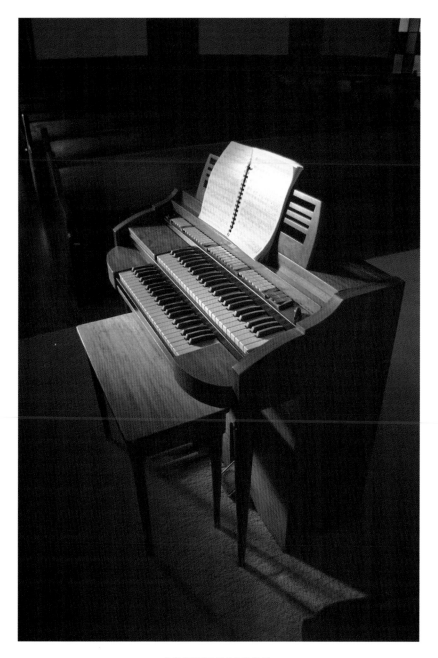

LOWNDESBORO

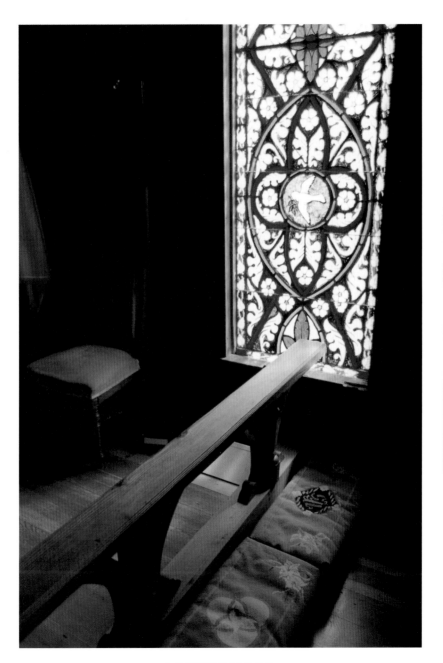

LOWNDESBORO

WHEN I'D FINISHED I SAT ON the corner of Phil's father's stone and smoked a cigarette and enjoyed the utter quiet of that country graveyard. I watched the Spanish moss swaying, swaying, in the two live oaks by the gate. I was in a kind of spell when I left, peaceful, thinking placidly . . . of all the generations which had passed this way since the Spaniards landed in 1519.

—EUGENE WALTER
"The Back-Roads"

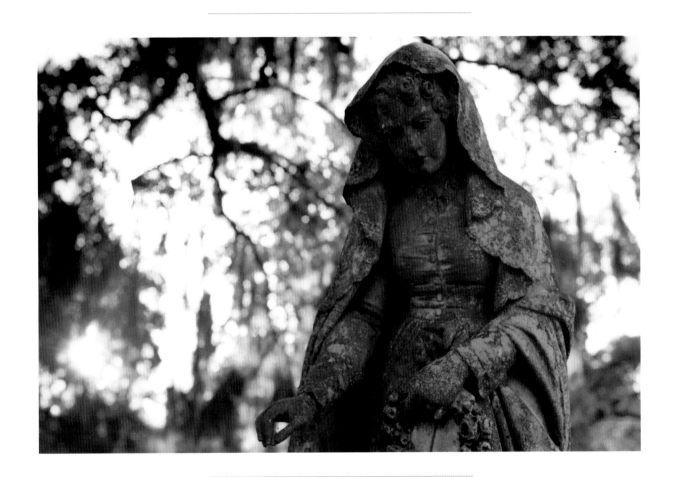

SELMA

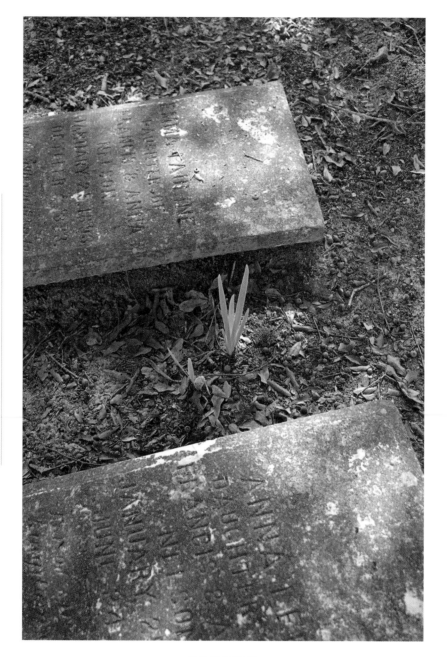

NEWBERN

I'VE BURIED MY MAMA AND I'VE BURIED MY PA

They sleep up the street beside that pretty brick wall

I bring 'em flowers about every day

But I just gotta cry when I think what they'd say...

Go on now and say goodbye to our town, to our town

Can't you see the sun's setting down on our town,

 on our town,

Goodnight

—IRIS DEMENT
"Our Town"

ACKNOWLEDGMENTS

There are a number of people who provided advice, inspiration, and encouragement during the course of this endeavor whom I would like to thank.

The genesis for this book came from an idea by a friend, publisher Bobby Frese, to do a book about Monroeville, Alabama, with photographs of the town and quotes from Monroeville writers like Harper Lee and Truman Capote. He asked me to make an exploratory trip down there to take some photographs and to see what the possibilities were. (The trip got off to a peculiar start when, only a few miles from home, a mockingbird flew into my car and was killed.) We later expanded the idea to include towns throughout the state, and during the next few years I attempted to visit towns in as many different parts of the state as time would allow.

Photographic inspiration for this book came also through Bobby Frese, when he asked me to design the book *Faulkner's Mississippi*, with photographs by the legendary Memphis photographer William Eggleston. I was lucky enough to spend a weekend in Memphis going through boxes of photographs with Eggleston, and they transformed the way I saw. I became instantly a disciple (unbeknownst to him, of course), and while I have attempted to emulate his approach, I could never emulate his eye.

In addition, I would like to thank William Christenberry for some kind words of encouragement during a workshop he gave at the Birmingham Museum of Art a few years ago.

My good friend Marie Martin has provided continuous aesthetic advice during the course of this project, critiquing the pictures as I took them and

helping with the final selection. Without her encouragement this book would probably not have been completed.

For the last twelve years I have had the pleasure of designing *Alabama Heritage*, and a number of these photographs were taken on photographic trips for the magazine. I would like to thank Suzanne Wolfe, Jennifer Horne, Stuart Flynn, T. J. Beitelman, Baker Lawley, Sara Martin, and Donna Cox for their patience by the side of the road while I went off to take pictures for myself. Several of these photographs were first published in the *Alabama Heritage* calendar "Southern Light" in 1995.

I would also like to thank those people who allowed me access to their homes, in particular David Woods of Newbern.

Others who have provided advice and encouragement include Ellen Sullivan, John and Sara Jones, Linda Nelson, Jack Hoos, my sisters Alison Glascock and Penelope Myers, my mother, Renée McDonald, and, of course, my own family—who spent more time waiting by the side of the road than anyone—my wife Debbie and sons Christopher and Shaun.

Finally, I would like to thank the people at The University of Alabama Press who helped to make this book a reality. And to Bob Gamble who provided the kind words for the foreword, many thanks.

One last thought. None of these photographs should be taken as representing the totality of any of these towns or my feelings about them. The things that appeal to my eye—the colors and textures of age, decline, even decay—would not appeal to the average Chamber of Commerce. I am not a booster or a critic. The things I photograph are the things I love.

—Robin McDonald
Leeds, Alabama

Dement, Iris. "Our Town," from the *Infamous Angel* CD. Copyright © 1992 by Songs of Iris. Reprinted by Permission of Songs of Iris.

Ellison, Ralph. "The Golden Day," from *Invisible Man* by Ralph Ellison. Random House. Copyright © 1947, 1948, 1952 by Ralph Ellison. Reprinted by permission of Random House.

Fitzgerald, Zelda. "Miss Ella," from *Zelda Fitzgerald: The Collected Writings*, edited by Matthew J. Bruccoli. Reprinted with permission of Scribner, an imprint of Simon & Schuster Adult Publishing Group, Copyright © 1931 by Charles Scribner's Sons. Copyright renewed © 1959 by Frances Scott Fitzgerald Lanahan. Originally published in *Scribner's Magazine*, December 1931.

Grau, Shirley Ann. "White Girl, Fine Girl," from *The Black Prince and Other Stories*. Knopf. Copyright © 1954 by Shirley Ann Grau. Reprinted by permission of JCA Literary Agency.

Hassell, Harrriet. "History of the South." Originally published in *Story Magazine*, 1938.

Kinkaid, Nanci. "The Other Sun of God," from *The Remembered Gate,* edited by Jay Lamar and Jeanie Thompson. Copyright © 2002 by The University of Alabama Press. Reprinted by permission.

Lee, Harper. *To Kill a Mockingbird.* Copyright © 1960 by Harper Lee. Reprinted by permission of the author.

Liddell, Viola Goode. *A Place of Springs.* The University of Alabama Press, 1982. Copyright © 1982 by The University of Alabama Press. Reprinted by permission.

Lincoln, C. Eric. "The Fire in Alabama," from *Coming Through the Fire: Surviving Race and Place in America.* Copyright © 1996 by Duke University Press. Used by permission.

March, William. "Not Worthy of a Wentworth," from *Trial Balance.* Copyright © 1945 by William March. Reprinted by permission of Harold Ober Associates.

Murray, Albert. *The Spyglass Tree.* Copyright © 1991 by Albert Murray. Random House Publishing/Pantheon Books.

Walter, Eugene. "The Byzantine Riddle," from *The Byzantine Riddle and Other Stories by Eugene Walter.* Copyright © 1980 by Eugene Walter. Reprinted by permission of Don Goodman.

Wilson, Augusta Evans. "The Old General and the Lost Granddaughter," from *At the Mercy of Tiberius.* A. L. Burt Company, 1887.

Vines, Howell. "The Ginseng Gatherers." Originally published in *The Southern Review* 1 (July 1935–Spring 1936). Reprinted by permission of Carolyn Vines.

ABOUT ROBIN McDONALD

Robin McDonald is an award-winning freelance photographer and graphic designer. Born in London, England, he immigrated to the United States and has lived in Alabama since his boyhood. He received a master's degree in art history from Columbia University in 1973 and served as the art director of *Horizon* Magazine. While at *Horizon*, McDonald won a Gold Award for art direction of photography and a Bronze Award for design from the New York Art Director's Club. In 1978 he won the Best of Show award in the Greater Birmingham Arts Alliance Annual Juried Photography Competition, and his photographs have appeared on the cover of several University of Alabama Press books, including Mary Ward Brown's *It Wasn't All Dancing* and W. Stuart Harris's *Dead Towns of Alabama*.